W9-BYM-024

CROSS-WIRED

—COMMUNICATION—INTERFACE—LOCALITY—

edited by
Simon Yuill and Kerstin Mey

School of Fine Art

Duncan of Jordanstone College of Art and Design
a Faculty of the
University of Dundee

with

Manchester University Press

MANCHESTER AND NEW YORK

FOUNDER EDITOR
Alan Woods

EDITORS
Simon Yuill, Kerstin Mey

SERIES EDITORS
Kerstin Mey, Euan McArthur

ADVISORY BOARD
Lynn A. Higgins, Susan Hiller, Jane Lee, Christoph Tannert

DESIGNER
Donald Addison

PUBLISHER
Manchester University Press,
Oxford Road, Manchester, M13 9NR,
and Room 400, 175 Fifth Avenue, New York, NY 10010, USA
www.manchesteruniversitypress.co.uk
in association with transcript,
School of Fine Art,
Duncan of Jordanstone College of Art and Design,
a Faculty of the University of Dundee

Distributed exclusively in the USA by
Palgrave, 175 Fifth Avenue, New York, NY 10010, USA
Distributed exclusively in Canada by
UBC Press, University of British Columbia, 2029 West Mall,
Vancouver, BC, Canada, V6T 1ZT

British Library Cataloging-in-Publication Data
A catalogue record for this publication is available from the British Library
Library of Congress Cataloging-in-Publication Data applied for

ISBN 0 7190 7036 8 hardback

EAN 978 0 7190 7036 5

ISBN 0 7190 7037 6 paperback

EAN 978 0 7190 7037 2

COPYRIGHT © FOR TEXTS the Authors
© FOR IMAGES the Artists, Photographers and Galleries as listed
© FOR PUBLICATION the Publishers

The views and comments stated within this publication do not necessarily represent
the views of the editors, the School of Fine Art, the Faculty DJCAD,
the University of Dundee or Manchester University Press.

Printed in Great Britain by CPI, Bath

Contents

Introduction

BILL SEAMAN'S PHRASE: 'how one code talks to another code' could possibly sum up the various contributions to this volume of the *transcript* book series. These 'conversations' between code systems take on a variety of forms: critical, constructive, disquieting, destructive and humorous. The codes are operated through a variety of media and facilitate the functioning of a range of different activities: computer programming, commerce, mobile communications, bureaucratic forms and school reports, the artworld itself. The functioning of art in society is, in Niklas Luhmann's account, integrally bound to the creation and dissemination of coding. Such codings express the lines of differentiation between conventions such as art and non-art, nature and culture, the beautiful and the mundane. They vary in historical and cultural context. The artists contributing to this publication do not simply subscribe to, or operate within the confines, of singular specific codes but rather seek ways of working between them, of cross-wiring one system into another. In Luhmann's words, they use codes as 'observational devices . . . mobile structures that are applied differently from situation to situation'.[1]

Seaman works with a very explicit notion of codes. He investigates how computer language codes might extend into forms of everyday language (parole) through the use of what he calls 'media-elements' (such as video images) as building blocks in a new form of grammatic medium (in Derrida's sense of the 'grammatic' as the basic differentiation marks of a writing system). He describes his work as 'a new way of thinking about linguistics'. It is one that draws parallels with Pierre Levy's proposals for a new ideographic 'superlanguage', exploiting the possibilities of widespread media technologies. Seaman, himself, comes out of a long line of artist-researchers exploring the application of new technologies, computing in particular, to artistic practice which became a distinctive facet of late-twentieth-century culture. Characterised in the work of Mary Beth Ellen, a pioneer of electronic imaging who worked with the inventor Leon Theremin in the 1950s, John Whitney, a later audio-visual experimenter who invented his own prototype computers to create his work, and Ken Knowlton, the inventor of BEFLEX, one of the first computer languages specifically designed for creating graphics.

JODI, similarly, work with computer code as a medium in its own right. This is approached from an entirely different perspective to that of Seaman however. JODI describe themselves as self-confessed 'amateurs'. They open up the fissures in the systematic, regulated structures which hold conventional software together (such as the desktop interface and the components of an email message) and let code flow through. If Seaman is a kind of Joshua Reynolds of new media, a grand academician of the medium, then JODI are the Chaim Soutines of the digital: mavericks whose work has been met with miscomprehension and condemnation by those who claim to be experts within the field of new media. Their material for *transcript* was originally

1. Niklas Luhmann, *Art as a Social System*, trans. by Eva M. Knodt, Stanford, Stanford University Press, 2000, p.187.

produced as a contribution to Circus-Web, a large international conference on new media which took place in Glasgow in March 2001. Its organisers make the claim that their 'research agenda has been led by the concept of creative pull, a concept which gives priority, even control, to the creative maker or user in the development of technological capability'. JODI made their contribution, not through the conventions of an academic paper but rather through posting their own exploration of 'technological capability' to the conference web site's bulletin-board, a platform specifically set up for open discussion on the conference themes. The reaction of the organisers was to repeatedly delete their work from the bulletin board. It appears that creativity may only 'pull' academic research when it does so in conformance with academic norms. Fortunately, JODI made screen-grabs of the Circus-Web contribution and we are proud to be able to present, and preserve, it here in old-media print.

Ironically, their practice stems from an 'old-fashioned' Modernist principle of exploring the singular differentiating qualities of a particular medium. They have done so, however, not through the rarefied 'mastering' of the digital but through an effort to explore its weaknesses. Their work derives from the experience of computer crashes, viruses and errors in coding, applied in their work here to the medium of the mailing list. The rejection of JODI's work is indicative of the disturbance created when new codes of artistic (or other) production confront existing ones. JODI's interventions, and similar such 'spam-art' as it has been labelled, is perceived, and treated, as undesirable 'noise'. Such contributions to one particular arts mailing list were dismissed as 'ascii crap' by one of its more prominent writers. Here we confront the age-old syndrome of equating non-conformist communication with a lack of toilet training, the response to which, so frequently and disappointingly, is often to construct new, stricter, normative codes of socially desirable behaviour. In the case of mailing lists, this has taken the form of 'netiquette'. What JODI's *messboard* reminds us is that the information highway is also the *cloaca maxima* of global media. Just as the ancient Romans prized the human excrement which ran through the city sewers to fertilise their crops, so too should we value the 'noise' which JODI create. There is perhaps no better indicator of a healthy, thriving cultural and social phenomenon than the amount of noise it produces: 'Each network pushes its organisation to the extreme, to the point where it creates the internal conditions for its own rupture, its own noises. What is noise to the old order is harmony to the new . . . '[2]

In a society, which is increasingly constructed through its digital communications, messing with digital codes is, directly, also a messing with cultural codes. Spinning the metaphor of our title once more, they are cross-wired into one another. The two sides of this circuit are analysed by Cornelia Sollfrank and Florian Cramer in their discussion, invoking Thomas Wulffen's notion of the 'art operating system'. Sollfrank, one of the founders of the *Old Boys Network,* has explored this practically, being active within various different operating systems including computer-hacker groups, like the 'Chaos Computer Club'. Through strategies such as her fictitious female hacker, Clara s0pht, she has exposed the social coding of such groups beyond the terms of gender identities. Sollfrank's in(ter)ventions draw on the legacy of Conceptual Art practice which has evolved in an intertwining relationship

2. Jacques Attali, *Noise: The Political Economy of Music,* trans. by Brian Massumi, Minneapolis/ London, University of Minnesota Press, 1985, p.35.

with computer-based art, a prime example being Hans Haacke's *Visitor's Profile,* 1972, which was the first use of a database system as artistic product. The arguments of Lawrence Alloway's 1973 essay *Network: The Art World Described as a System,* which addressed the changes in the art scene of its time, are echoed in Sollfrank's own analysis of the 'art operating system': 'What belongs to the operating system is the concept of the artist, the notion of an artistic program, an artist's body of work, and last but not least the interfaces—who and what will be exhibited and who will look at it.'

Sollfrank's own practice, operating as artist, curator, theorist and journalist, embodies Alloway's model of the late-twentieth-century art scene as one in which 'the participants can move functionally within a cooperative system'.[3] The internet as medium exemplifies the status of the art object 'as part of a spectrum of objects and messages'.[4] In Alloway's account it is the manner of distribution and consumption of art which is the output of the contemporary artworld system. It is this which most strongly characterises it rather than artworks in their own right, as any object, or concept, which is distributed and consumed through these mechanisms operates as 'art' regardless of its origins. In this sense the artworld operates through a set of interfaces, organising our perception and recognition of various sets of productive and communicative processes, just as the computer desktop interface organises our perception of computer code systems as folders, documents and email messages.

In Nina Pope's *A Public Auction of Private Art Works* contemporary artistic practice engages with a context of dissemination normally reserved for grand masters and antiques: the auction of a country estate's household collection. Pope is utilising an 'interface' which post-Conceptual art had distanced itself from long ago. This context could serve as a satire on urban 'High Art Lite' brought into the realms of the *Antiques Roadshow* (the auction itself being conducted by one of the evaluators from this great British television institution), but instead serves, more thoughtfully, as an unfolding of subtle notions of value relating objects to personal histories and localities explored through the codes of an essentially economic commercial mechanism. Despite the contrasts of style and spirit, its concerns are not so sharply removed from those of Santiago Sierra's work which similarly utilises the structures of commercial transaction as its basis. The contrast between Pope's auction and Sierra's remuneration series can be described as follows: whereas Pope unearths the persistence of personal, contingent histories, Sierra enacts the erasure of self and historical identity brought about through a human being's submission to the terms and codes of a contract. It is the exposure of what the contract allows, how it rewrites identity and patterns behaviour which we see in much of Sierra's work, an aesthetics of human resources and monetary exchange of late capitalism allowed to turn in on itself.

High art and commerce, however, have always been bedfellows, regardless of any delusion of artistic neutrality or independence from commercial practice, which has infected art at least since nineteenth century Romanticism, and its concurrent adoption as a middle-class past-time. As Alloway argued, contemporary Western art is not so much distinguished and shaped by its products as by its distributive mechanisms. Julian Stallabrass has explored this phenomenon in the current British artscene, emphasising

3. Lawrence Alloway, 'Network: The Art World Described as a System', in *Network: Art and the Complex Present,* Ann Arbor, UMI Research Press, 1984, p.4.

4. *Ibid.,* p.8.

in particular the impact of advertising and the aspirations (of artists, collectors and critics) for media celebrity that have attended it. The commercial basis from which the artworld acquires its shape, both in Alloway's and Stallabrass's accounts, can be summed up in a remark quoted by Stallabrass from his *bête noire,* Damien Hirst: 'a logo as an idea of myself as an artist'.[5]

Paul Rand, the designer of IBM's logo as well as those of many other major American corporations, identified the logo, or trademark, as the artform of the twentieth century. These small patterns of identity have come to exemplify contemporary life, and economy, so strongly that their active denial became the rallying cry of popular protest captured by Naomi Klein's *No Logo* . . . emblazoned however across t-shirts, books and coffee mugs. This ironic submission to the commercial is the playground of COM & COM's stance as 'Art Jockeys' that satirises not so much the commercialisation of art and the celebrity cult, but rather the artworld's self-denial of commerce's influence within it. Their work comes into being as a confluence of various 'operating systems' such as advertising, club culture, film marketing, etc., and their respective grammars.

RTMark's work is more strategic, and social, having carefully re-wired the relations between art and business. They have exploited the loopholes of artistic and corporate liability to provide openings for social and political critique in contexts where it rarely emerges: presidential campaigns, World Trade summits and the media. For RTMark, the logo and its online equivalent, the web address, can be a weapon and a snare as demonstrated in their re-workings of George W. Bush's campaign web-sites, the GATT internet sites, and their appearances as fake delegates at WTO conferences. But they go beyond parody using the actual structure of a registered corporation as a means of providing funding and legal protection to political and anti-capital activism.

Lee Bul's works oscillate between Eastern and Western contemporary life and cultural traditions: high tech, cyborgs and mythology, private desires and anxieties, and social themes. Many of them draw on culturally ingrained stereotypes of femininity. In her *Hydra* project the mythical Greek monster with its nine heads and poisonous breath is fused with the inflated stereotype of the beautiful, subservient Asian woman as constructed by Western Orientalism past and present. Bul turns the latter into provocative images of monstrous female sexuality where evil persistently lurks beneath the surface of playful and enticing aestheticisation. In a peculiar way, these monstrous femme fatales echo the roar of the potent Asian Tiger economies during the 1990s and their persistent threat to western economic as well as political and cultural hegemony. Like most of Bul's work they take issue with the deflating sexualisation and (an)aestheticisation of current social and cultural phenomena.

Perhaps the least technologically-concerned contributor, Yasuko Toyoshima, comments most clearly on the play of codes as 'observational devices' in daily life. Mundane bureaucratic media, such as application forms and school reports, as well as the technologies of pencils and rulers which accompany them, are re-routed in another direction. Away from the systemisation of personal identity as institutional data towards the defiant expansion of self-presence, filling the blank margins of the bureaucratic

5. Julian Stallabrass, *High Art Lite*, London, Verso, 1999, p.64.

interface (such as a school exam paper) so as 'to shift as many daily necessities and systems to myself and my way of thinking'. Toyoshima's defiance is low-key and humorous but succeeds as a series of momentary subversions, of life between the bureaucratic codes. The codes of contemporary Western art—which Toyoshima mentions as being seen as 'imported into Japan'—are consciously utilised as a kind of observational device for pursuing this. Contrary to the notion of a universal 'superlanguage', such as that proposed by Levy, Toyoshima speaks of the need for an appreciation of the variety of localised cultural systems. She suggests a positive form of 'misunderstanding' through which the acknowledgement of cultural differences can be a space of opportunity on behalf of the recipient culture. A less macho parallel to Harold Bloom's notion of the necessity of misunderstanding one's influences in order to innovate, it suggests a tactic for cultural self-assertion in countries which may be forced into a form of 'recipient' status by Western media's global hegemony.

Working from within the country most closely associated with that domineering media, Cary Peppermint's work can be taken as a kind of a quest for moments of localisation in an a-terrestrial medium. Point Of Presence (POP) is a protocol through which online email deliveries can be downloaded to a local hard-drive. The *pop_accounts* series is a journal of mappings between a trip through America's mid-West and virtual mail-boxes. It is a reversal of the Renaissance Memory Theatres. This was a mnemonic technique (originally derived from the Classical rhetoric tradition) through which the concepts and themes of a speech, religious lesson or intellectual system, were associated with the images of real places in order to reinforce their memory and aide in recollecting them by imaginatively walking through the places. The technique influenced the art of its time resulting in paintings and sculptural *tableaux* combining Biblical personae with contemporary public figures set in Italian city-streets. The technique also inspired the development of the desktop interface and its use of labelled icons. But whereas the Memory Theatre technique makes an intangible idea more concrete by linking it to a tangible place, Peppermint's *pop_accounts* transfer the physical site of a snapshot event to a virtual deposit box. It is not the physical location we return to for recall but the scattering of data-packets and digital mailrooms.

The Memory Theatre was a form of portable data assistant. Imagery derived from, and intended to support, the use of Memory Theatre techniques was also present in public urban space—the streets of fifteenth-century Florence, for example, were known not by names but by certain iconic images which adorned them. Personal internal and public external space became saturated with systems, which conflated conceptual and geographic navigation. The current development of mobile technologies appears to extend this influence in mass media from its first appearance in sixteenth-century books and broadsheets to the desktop prototypes of the 1970s and the location-sensitive services promised by the advent of wireless technologies. Whilst its modes of use are perhaps more strongly shaped by nineteenth-century practice, the art gallery is similarly a descendent of the Renaissance when the dual notions of the private art collection and the patronage of public art came into shape. In the discussion between Matt

Locke (Creative Director for the BBC's r'n'd Imagineering department), Matthew Chalmers (researcher on the Equator project into mobile, location sensitive data systems), and Francis McKee (new media director of Glasgow's Centre for Contemporary Art), the impact of mobile technologies on the conventionally static gallery space is explored. Chalmers proposes the possibility of 'hacking' curatorial control over the display and interpretational framing of gallery exhibits, whilst Locke comments on his experience of working on various urban-based mobile projects, such as Forced Entertainment's *Surrender Control* and the significance of understanding human use of urban space as a social medium which such technologies may augment. If Alloway's model of distribution as key differentiator of artistic paradigm shift holds, then these models perhaps suggest the most significant change from late-twentieth century practice. In describing these, Locke invokes not the Renaissance (the concept of the digital era as a new Renaissance has, after all, become an over-worn cliché) but the nineteenth-century *flâneur*. So is the mobile era the new *fin de siècle?* Hardly, such historical references are simply another form of 'observational device', a means of constructing pattern when existing cultural paradigms become unsettled. What the arguments of this discussion suggest is that the socio-spatial experience of cultural engagement becomes more layered, super-imposing static architectural contexts (such as the gallery) with more dynamic, ephemeral, content-structures, like a form of digital (but also social) graffiti.

It is not all codes, concepts and constructs however. Judy Spark's study in 'electro-mist' reminds us of an obvious but often overlooked aspect of new media culture. The nineteenth-century advancements in industrial chemical manufacture facilitated the creation of new paint colours and paint media which enabled new approaches to the practice of painting—such as the bright colours of Fauvism, the outdoor impromtu styles of Impression (impossible without the new portable tubes of pre-mixed paint), and the later flat colour fields characteristic of so much twentieth-century painting. Artists such as Spark and, elsewhere, Anthony Dunne have begun to explore the full extent of current culture's material basis in the exploitation of the electromagnetic spectrum (a material which we learn is, like oil paint, susceptible to heat and moisture). It is the diffuse, blanket-like dissemination of the electromagnetic which carries our mobile connectivity. Spark's investigation demonstrates that it is not only urban space that has become technologised but that also the notion and possibility of 'remoteness' is disappearing under the cellular network. The nineteenth-century *flâneur* drifted, unnoticed, around the city-scape. The twenty-first century counterpart is a point of presence within a network of communication codes, monitored, located—whether that be in a shopping mall or a Highland glen. Perhaps, therefore, if there is anything which significantly distinguishes early twenty-first-century cultural practices from those of previous eras, it is not the dissemination and consumption of art objects and media content but rather the dissemination and consumption of audience presence.

SIMON YUILL AND KERSTIN MEY, NOVEMBER 2002

Recombinant Poetics

becoming

energy circulates interauthoring the meeting fields
motion becomes clear, sending and receiving coded signals
light becomes information, response fields activated
the alchemical metaphor becomes code, lines of coded motion and response
information becomes light, paths and returns
light becomes thought, trajectories and relays
thought becomes action, enfolded in response
water becomes steam, the circulatory fold
thought becomes force, transference states
energy becomes action, circulation informs the fields
thought becomes energy, a return that inter-folds
sand becomes thought, the physics of emotion dispersion
a body becomes entangled with another thought
bodies become heated, circulating emotives
bodies become attracted, going inward
eroticism becomes heightened, time-signals are trangressed
tongues become one form of dance, electric
tastes become one, the plural articulation
silence becomes circulatory, angular musculature of the body-song
machines become music, push spill, pinion distortion
thought becomes a machine, grasping balance
sexuality becomes a linguistics, the clock of space
dance becomes language, a return that folds
language becomes gestural, reacting with precision
gesture becomes light, hand measures, trigger fields
motion becomes erotic, the touch field distances
the boundary becomes a bridge, pulse edges
a container becomes activated, abbreviated
a vessel becomes engaged, inter fields of energy
containers become saturated, held in the air
a motion becomes ecstasy, a balance of contortions
energy becomes transgressive of dissipation in circulating
freedom becomes costly, no sliding off
touch becomes arousal, the tensile surface organisation
emotion becomes confused, the angular dimensions of release
vapour becomes a body, the woven arms inverted, inserted
breathing becomes energy, the voice of exchange
the body becomes a battery, the musculature of containment
a battery becomes a litany, transference states
a process becomes a physicality, rivers flow into larger bodies
a word becomes a plurality, folding across the intervals
a plurality becomes a oneness, the musculature of the articulation
a boundary becomes amorphous, the alternate perspective, fine hairs
a site becomes the body cathartic, the body of information
mining becomes information, the meeting fields
a gesture becomes informed, grasping balance
motion becomes poignant, grafting emotives
an angle becomes a path to navigate through not knowing
motion becomes you, emergent of flows

Bill Seaman
in conversation with
Yvonne Spielmann

BILL SEAMAN

Artist and Professor, PhD
Program Head
Digital Media Program
Rhode Island School of Design, USA

Born 1956 in Kennet, Missouri, USA
Lives and works in Baltimore

YVONNE SPIELMANN

Professor of Visual Media
Art Academy Braunschweig,
Germany

Born 1957 in Heidelberg, Germany
Lives and works in Berlin and
Braunschweig

Since the late seventies/early eighties BILL SEAMAN has been working with linear videotape and he has carried on the preoccupation with this medium in the installation works that combine videodisk with computer-driven menu systems. He has also repeatedly made different versions of the same piece, like a videotape and a CD-ROM for the *Exquisite Mechanism of Shivers* (1991/1994). Even when he approaches interactive media in the installation *Passage Sets/One Pulls Pivots at the Tip of the Tongue* (1995) he also has a linear videotape that uses the same audiovisual materials. Also the projection of video sequences on large-scale screen seems to be crucial in a number of his multimedia installations like *Exchange Fields* (2000). In *Exchange Fields* the viewer/user rather physically interacts with a computer program steering certain video sequences that are projected next to images from linear videotape through positioning themselves in relation to sculptural/furniture objects. This work reveals a choreography of different movements, where the interactive participant has to move from one furniture/sculpture to another in order to activate through immediate physical contact different passages of a dance movement. These movements are performed on a projection screen in such ways that video sequences build layers transparent to each other according to the multiplicity of interactive impulses given by a certain number of participants at a time. Similar to this high complexity of movements causing spatial density in *Exchange Fields*, the earlier virtual reality work *The World Generator/The Engine of Desire*, with programmer Gideon May (1996/98) asks the participant to 'generate' from a given menu system, the interrelation of virtual objects along with texts and music, and also define their interacting and moving qualities. On the one hand, the participant (viewer/user) in these interactive works becomes more and more the 'author' or even creator of a multidimensional virtual world, through which s/he navigates while the visual material unfolds spatially and also temporally on a large screen, whereas on the other hand the processing of image, sound, and text relies upon certain predefined structuring principles, some of those are more fixed, such as the digital video, while others are rather open-ended or elements are loosely connected through hyperlinks and virtual proximity. There are at least two sides of creativity that characterise the encounter with the machine. This approach becomes even more evident in his recent piece *Red Dice* (2000) that incorporates a poem (a written text) and develops text into non-linear, circular and overlapped readings, that is also expanded and accumulates its meaning through accompanied visuals, related text and music. Many of the images explore engines and physical objects. Here again, the work has an open ordering structure and the interactive process will only reinforce Seaman's major concern to recombine text and other semiotic/ linguistic patterns. While at the same time the videotape *Red Dice* emphasises a meditative quality in the same materials, when an associative montage, more precisely a combination of slow motion images, a musical

score, spoken words and written texts that loosely relate to each other, guide the viewer. These 'passages' through images, sound/music, and written or spoken texts, that many of his works represent, demonstrate in particular a strategy to work with different media in such ways that elements affect each other through combination, a sort of combination that conveys not only different media elements but also immerses the viewer and participant into web-like patterns.

YVONNE SPIELMANN In taking your interest in linguistics, video, and interactivity as a starting point I would like to talk about the interrelationship between differing media, in particular between image and text and also talk about the question if there is a leading medium and even some sort of hierarchical order albeit the evidently synaesthetic approaches in your work.

BILL SEAMAN I am very much interested in image/music/text relations, really thinking about those media elements all as linguistic elements—a kind of new way of thinking about linguistics, where sound and image function as language-vehicles. In particular I have been developing an idea I call recombinant poetics. I am very much interested in combinatorial structures where non-hierarchical relations between image, text and sound or music can be explored by someone who is interacting. In particular I am interested in how emergent meaning arises through this interaction. Part of what I try to focus on is making a module or a certain media element which is already a field of potential meanings. For example I might choose a pun as part of the poetic text so that a whole series of different meanings might arise in different contexts.

Recombinant Poetics

SPIELMANN To what extent does it demonstrate a general idea when you deal with existing text and language and rework them in such ways that will intentionally expand inherent meaning of the previous text into a new multiplicity?

SEAMAN In my PhD dissertation *Recombinant Poetics: Emergent Meaning as Examined and Explored Within a Specific Generative Virtual Environment* I write about the idea of fields of meaning and taking the idea of linguistics into a new area where the text has a certain kind of meaning force as a field. Also the image has a kind of meaning force as a field and so does the sound. We also bring a history of our relationships with other environments so we might say that our mind-set is also a field. There is a dynamic summing of these forces we are weighing against each other and the meaning arises out of this. For me the relationship is non-hierarchical, there is not a greater weighting of the text over the sound or over the image but they are always in dynamic relation to one another. In my earlier work this was much more screen based but still looking at context, decontextualisation and recontextualisation. Now, I am moving the context out of the screen and really engaging the participant or the viewer/user (I coined the word 'vuser') with the larger environment so that they palpably, become physically aware of their field and how it is related to the other field of the media elements.

Passage Sets

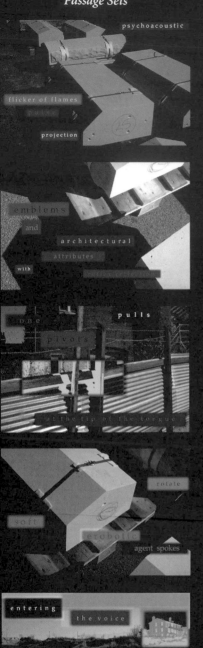

SPIELMANN In the recent piece *Red Dice/Dés Chiffré* (Ottawa, 2000) you enlarge on Stéphane Mallarmé's poem *Un coup de dés jamais n'abolira le hasard* (Dice Thrown Never Will Annul Chance) in an intertextual manner through putting new layers that comment upon and exist in relation to the existing poetic text so that finally the original language expands into your own media experience.[1]

SEAMAN The earlier piece *Passage Sets/One Pulls Pivots at the Tip of the Tongue* was already influenced by Mallarmé's *Dice Thrown Never Will Annul Chance*. Mallarmé had made a form of spatial text that for me was one of the first moments where someone could navigate through the text in differing ways, where multiple meanings might arise depending on how they were moving over the surface of this text.

 I was then commissioned by the National Gallery of Canada to do this piece on Mallarmé's text, where I developed the idea that Mallarmé's approach to writing was to his time as my approach to computer-related media as an authored expression is to my time. So a number of the images are industrial machines like the player piano, the mill, the turbine that are in use at his period of time. In particular, there are images of weaving and powerlooms, and of course the powerloom later became the computer. I created a metatext which points at Mallarmé's text and is a media-poem in its own right so that there are points where other attributes of new media and the idea of recombinant poetics come in. Where in Mallarmé's poem different words are woven to create the (pun) textile, in mine the weaving gets translated into interactivity which means literally recombining fragments of my text, image and muscial segments in a generative form.

SPIELMANN I would like to take further the notion of recombination and ask how you can maintain the idea of open structure and generative form when you conceive a videotape. *Passage Sets*, as well as *Red Dice* and other works, have a video version that is a work in its own right, but at the same time the video is an integral part of a larger installation where the same material gets surrounded by texts projected onto screen. Moreover, a user's menu enables the viewer/user to interfere and make changes. Does video hold an intermediary position in relation to a non-linear stage of interactivity in this multimedia context?

SEAMAN I really think of the video pieces as works that are complete in their own right. The interactive works are focusing on different principles and the video works inform the interactive installations. For example, the linear version of *Passage Sets* is a thirty-minute tape that has spoken text, music that I have composed and images that I have shot, where there is a suspended, almost hypnotic, kind of linear time. In the installation version one experiences a quite different state for that medium. In general, I am very interested in the notion of context and recontextualisation and how new meanings arise when you explore recontextualisation. I am also interested in words and images that are open in meaning even when they are fixed in a linear manner, because I have built a non-hierarchical structure between image, text and sound. When one watches these tapes they often shift between the layers. One might come back to the tape and see it a number of times and each time one might take away something different from the experience.

1. Stéphane Mallarmé, *Un coup de dés*, first edited in 1897, but not published until 1914, long after Mallarmé's death, in the typographical layout established by the author.
French/English editions:
Dice Thrown Never Will Annul Chance, a translation by Brian Coffey of *Un coup de dés jamais n'abolira le hasard*, a poem by Stéphane Mallarmé, Dublin, Dolmen Press, 1965.
The Meaning of Mallarmé. A bilingual edition of his 'Poésies' and 'Un coup de dés', translated and introduced by Charles Chadwick, Aberdeen, Scottish Cultural Press, 1996 (translation of the poem's title: *A Cast of the Dice Will Never*).

SPIELMANN I am interested in the use of montage and collage in the two works, *Passage Sets* and *Red Dice*, that seem to demonstrate your preoccupation with open-ended structures. Historically this refers to more traditional media such as literature and film, which are linear but in view of this can be regarded as precursors to hypermedia.

SEAMAN In both pieces, *Red Dice* and *Passage Sets / One Pulls Pivots at the Tip of the Tongue*, the videodisks are set up so that one can play various modules very easily, for example you can play back sections of linear video in different orders. *Passage Sets* was set up as a navigational poem and the interface was made of one hundred and fifty images with poetic text scattered over the surface of the image. One could navigate through the surface of this poem on one screen and then by selecting a particular 'passage' you could trigger a video and subsequently hear me speaking that part of the text and also hear music that went along with that section. One could click on the word, which would take you to what I call the 'poem generator': I had literally taken every word from the text and put them into categories. I actually deconstructed the way I wrote the text and then built those categories based on how I wrote the linear text initially, with the idea being that the interactant could shift and generate new poems. Every word in that section was hyperlinked back to the part of the larger text that it had come from. So you could always be reading the surface of the poem on the image or you could move and recontextualise the word and then go to a different context where that word is used. In this way the apparatus leads itself to playing back pieces in a discontinuous form. If we think of the notion of smooth and striated space from Gilles Deleuze and Félix Guattari, the video represents a smooth space and the interactive installation versions represent striated spaces—yet one informs the other—smooth space becomes striated and striated becomes smooth as discussed by Deleuze and Guattari.[2]

The computer-based installation of *Passage Sets* would be the striated space, because it is comprised of modular cuts—it plays back specific segments and every time grabs a still frame at the end of the sequence and holds that image on the screen. *Red Dice* is related—you are driving it with an electronic pen on a *Wacom* tablet-screen and herein lies a parallel between the writing of Mallarmé and a computer-pen. Unlike these striated interactive spaces, *The World Generator / The Engine of Desire* explores the smooth navigational space of virtual reality although it also contains elements of striated space in the menu system.

SPIELMANN What exactly then is the computer's contribution to achieve 'creativity' and to foster what you call 'meaning forces'?

SEAMAN Interestingly the biologist Humberto Maturana says a linguistic event is when there is a mutual ontogenic structural coupling between two people. Maturana provides this definition of the linguistic domain: 'The linguistic domain as a domain of orienting behaviour requires at least two interacting organisms with comparable domains of interactions, so that a cooperative system of consensual interactions may be developed in which the emerging conduct of the two organisms is relevant for both. The central feature of human existence is its occurrence in a linguistic cognitive domain. The domain is constitutively social.'[3]

Through this interactive structure the technology becomes an extension

2. 'No sooner do we note a simple opposition between two kinds of space than we must indicate a much more complex difference by virtue of which the successive terms of the oppositions fail to coincide entirely. And no sooner have we done that than we must remind ourselves that the two spaces in fact exist only in mixture: smooth space is constantly being translated, traversed into a striated space; striated space is constantly being reversed, returned to a smooth space.' Gilles Deleuze and Félix Guattari, *Mille Plateaux*, English edition: *A Thousand Plateaus. Capitalism and Schizophrenia*, Minneapolis, University of Minnesota Press, 1987, p. 474.

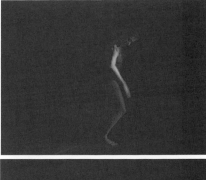

Exchange Fields

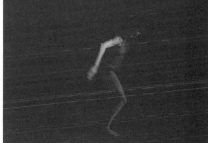

Exchange Fields

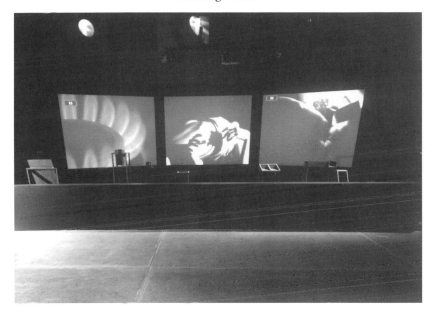

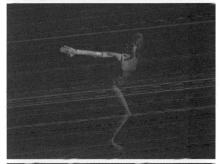

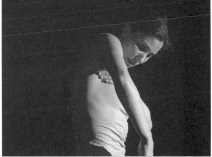

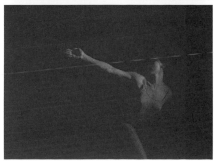

3. Humberto Maturana, 'Biology of Language: The Epistemology of Reality', in: G.A. Miller and E. Lenneberg, eds, *Psychology and Biology of Language and Thought: Essays in Honour of Eric Lenneberg,* New York, Academic Press, 1978, p. 41, XXIV.

4. 'The various conducts or behaviours are arbitrary because they can have any form as long as they operate as triggering perturbations in the interactions; they are contextual because their participation in the interlocked interactions of the domain is defined only with respect to the interactions that constitute the domain . . . I shall call the domain of interlocked conducts . . . a consensual domain.' H. Maturana and F. Varela, *Autopoiesis and Cognition,* Dordrecht/Boston/London, D. Reidel Publishing Co., 1980.

5. Jacques Derrida, *De la grammatologie,* English edition: *Of Grammatology,* Baltimore, Johns Hopkins University Press, 1998.

of my authorship—the ability to communicate through configurations of media elements as well as inter-authorship with the *vuser*. My feeling is that not only is the text linguistic, but the whole environment is a linguistic environment—through my reading of Maturana—a 'consensual domain',[4] where image, text and sound/music are all functioning as linguistic vehicles. I think that this is a contemporary approach to linguistics in a time of computers when we can cut, copy and paste media elements and juxtapose them in a spatial manner, catalogue them and operate on them as we see fit. We can also interactively explore the fleeting nature of how meaning shifts as media elements are recontextualised. All this is brought about through the mutability of the computer and the operative potentials of media elements, each providing a potential meaning force within this generative computer-based environment.

SPIELMANN I would like to investigate the linguistic model that you refer to in your writings and that also informs the web-like manner in which you assemble texts and images. Could you comment on the linguistic model and how you apply it to the artwork?

SEAMAN In my PhD dissertation I focused on two different aspects. One is the notion of *différance* from Jacques Derrida and his writing about the *prototext* and the *gram* in his book *Of Grammatology*.[5] In counter distinction to Derrida was the notion of mixed-semiotic milieus from Gilles Deleuze and Félix Guattari that they wrote about in *Mille Plateaux* (Eng. *A Thousand Plateaus*). Both of these approaches always seem to refer back somehow to the 'logocentric' even if a media-text is explored. What I am really saying is different, namely that the medium can also be *of itself* and that we do not necessarily make a text out of the medium in order to understand it. Thus text communicates differently to that of time-based images and to that of music/sound. In the kinds of non-hierarchical interactive environments that I am creating the word is not valued above the music/sound or image. They intermingle and become a non-logocentric mixed-semiotic conveyance.

A computer-based device like the *World Generator* becomes a discourse environment where one can literally experience how meanings arise and shift with the form of specificity that characterises each media element. While someone might have the argument that words are very specific and that we use them for the reason that they have a related set of meanings, in contrast, what I am suggesting is this: the complexity of the computer-oriented media-environments that we now inhabit suggests that we are constantly understanding that meaning is arising in contexts where text, image, and sound/music are all vehicles of meaning-force, and these language vehicles become operable as computer-based variables. More and more we live our lives in media-saturated environments, and mutable computer-based domains.

In computer environments an intermingling of communicative potential becomes evocative in a meaningful manner. Each media element acts upon the other in a dynamic, potentially non-hierarchical manner. This is particularly true in my environments although others may choose to explore the media elements differently, attributing different weights to an authored hierarchy. A composer may preference music but

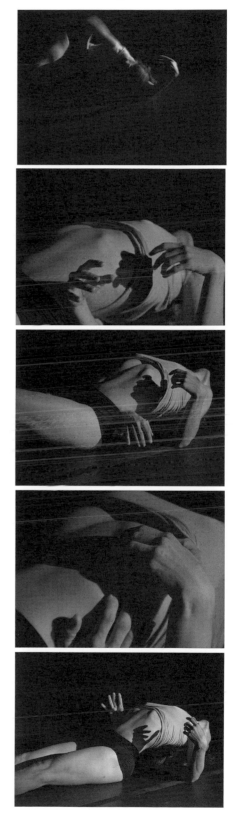

include text. A filmmaker may focus on images but also have a background music etc. There is a subtlety of relationships between these meaning forces that text alone cannot get at through description. Language is alive and is always relative to our ongoing construction of different contexts. The pen and the typewriter extended language and I believe the computer presents a potential of new sets of palpable extensions.

We might say that each of these computer-based media forms is of itself because there is something about the characteristics of digital video or film that you will lose by translating it into text. I am suggesting that there is a potential for a new kind of understanding of media interrelations through the perspective of a computer-based environmental linguistics. As I mentioned earlier, there are two general perspectives that one might employ to come to better understand these complex, shifting configurations of media elements—one is a computer-based mixed-semiotics and the other is a computer-based environmental linguistics as understood through the writings of Humberto Maturana and Francisco J. Varela. I am suggesting that meaning forces are functioning through operational language-vehicles within these mutable computer based environments. I believe that working toward a new environmental computer-based linguistic model is an interesting approach at this time.

Emergent Meaning

SPIELMANN By taking a closer look at computer models on the symbolic level where language, text, and whatsoever medium can be used to create forms of higher abstraction, I would like to focus on your understanding of the computer as a tool for abstraction as you have developed in the virtual reality piece *The World Generator*.

SEAMAN *The World Generator/The Engine of Desire* was my first exploration into virtual space. It used a new kind of menu system (programmed by Gideon May) with a series of spinning container-wheels. One could choose media elements— of text, image, sound/music, still frames, and digital video—and position them in a virtual environment. One could also attribute behaviours to those media elements. In a sense this suggests a new kind of linguistic space, certainly an operational relativistic meaning space. The underlying question was, if we were to say that reality and especially virtual reality is more complex than words' ability to reflect upon it, how might we generate a mechanism that would let us experience that complexity and be able to reflect upon the experience. For me *The World Generator* empowers one to explore meaning as it is emerging, because one can form a dynamic context by putting a poetic piece of text next to an image and/or sound element, and one can experience how these fields of meanings act upon each other. I can put a sound into the environment and navigate through the environment, and I can also explore different levels of abstraction of the media elements to the very point where they might become completely chaotic. One might call this an accretive meaning—one that is adding up over time. So I am working with similar principles to those explored in the earlier pieces, but where those works were much more modular and bound to the plane of

Exchange Fields

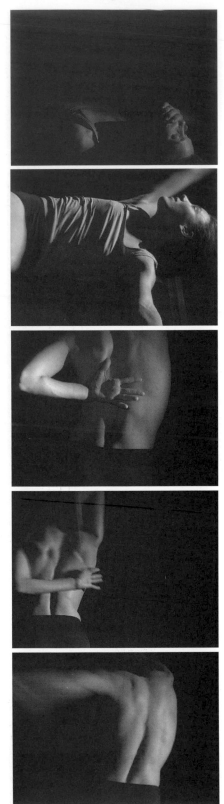

the image, in virtual space you literally navigate into and move through the image, sound and text, and thereby generate the experience in a different way. You literally are constructing the meaning from inside the experience.

SPIELMANN With regard to abstraction you were also saying that the way one might author virtual reality will 'literally' and not only conceptually affect our understanding of what is logic and what we experience as 'real' reality. Could you explain what you mean by 'abstract physics'?

SEAMAN The idea is that in the world around us there is a kind of physics, but as soon as we go inside the computer—especially in a virtual space— we make decisions about what makes up the physics of that space—it is an authored physics. We actually 'make' an abstract physics and this can be very realistic: we might see a cartoon where somebody looks like they are running and when falling down it looks as if there was gravity, but at the same time we can author a physics which is the opposite of that. If I drop something it falls up, if I take something I can stretch it or expand it and so on. So there is a new way of thinking about the relationship of actual space to virtual space. I now call this E-phany physics.

Interestingly, this approach to abstract physics also makes me rethink what I do in my video. Now I even think that to use slow motion in video is also a form of abstract physics. There is an actual physics of an event, of course there is light that I record, but once it is in the machine I can slow the image down or manipulate it in various ways and abstract the physics in a subtle way. If I then take that image and bring it into a virtual space, I can give it a further media behaviour and a totally separate kind of physics, which is very different from the tradition of images that we know.

SPIELMANN If there is a different quality of time and space in dealing with virtual reality, my question is: how far does the option of dimensions and directions reach? For example, I think of the reversibility of time and space, of the manipulation of movement and velocity so that time and space become elastic features—and finally the whole question of time and space dissolves. I am in particular referring to a media debate around Gilles Deleuze, Edmond Couchot, and others where the argument is held that with the emergence of electronic media and more precisely hypermedia the notion of direction and dimension loses its characteristic qualities since the new media are considered as omnidirectional and multidimensional, so that, strictly speaking, they have no such temporal and spatial features like painting, photography, and film, but reinforce what Deleuze calls 'whatsoever space' (*l'espace quelconque*). Does this make sense to your concept of abstraction?

SEAMAN I have not specifically defined my work with this term. I agree, such a space loses one set of qualities yet it gains another. We are now in the process of exploring this new set of potentials. I am very much interested in the definition of the 'rhizome': The concept of the 'rhizome' as developed by Deleuze and Guattari in *A Thousand Plateaus* is highly relevant to a discussion of a shifting configuration of media elements, as well as a conflation of language-vehicles where any point can be connected to any other point, etc.

However, I came to explore new relations to space through experimentation, intuition and interactive artistic practice. It was only

later when reading Deleuze and Guattari that I felt many of my ideas were reinforced from their perspective. So, yes, I see a new kind of spatial media that opens out a whole series of potentials of behavioural media relationships, as well as new relations to time and navigation—both from the behaviour of the participant as well as a notion of behavioural or reactive media. What I have in mind is that you author the system to behaviourally respond to a person. In the coming years, as Artificial Intelligence will become more easily accessible as an authoring tool, one could imagine highly relevant responsive media-reactions to one's interactivity within a particular environment.

SPIELMANN I like to discuss further what you describe as recombinant mode and generative process. Is there not a limit where the enforced increasing of complexity, multiplicity and polyvalent meaning pools somehow collapses and eventually turns into the contrary, eventually resulting in self-destruction? As we know this kind of ambiguity has been a major challenge for many artists working with machines, and the idea of self-destroying or self-consuming artifact had a strong impact on twentieth-century arts.

SEAMAN This is a very interesting question. I think that great poetic works always tend to have a kind of openness about the meaning such that each time one returns to the work, other layers of meaning are revealed. If we take this model where there is always a potential to release new meanings, I am interested in making a structure where one can experience an accretive meaning or one that is being added to over time as well as through contextual exploration. One becomes directly connected to the generative process of constructing alternate contexts. Even if the environment becomes completely chaotic, because one has been conceptually active through the entire process, then it potentially makes a more complex meaning as opposed to a dissolution of meaning. It is almost a paradoxical idea that as the further away you move from the initial meaning actually the more engaging and the more interesting meaning becomes because you are at the same time reflecting on how abstraction functions as a part of that meaning.

SPIELMANN My understanding of a paradoxical situation is that there are at least two opposing types of images or whatsoever media present at the same time and place and what becomes apparent and perceivable in an artwork is the point or process of combination. Mostly the resultant form will show a simultaneity of contradictory features, a new mixed form that was created through the paradoxical form.

SEAMAN I would suggest that paradox does exist normally and our ability to reflect on it through textual language is limited, but in a system like *The World Generator* you can observe paradox as it arises and you can participate with it as a conceptual entity over time. Thus a potential relation is provided in virtual reality that becomes a means to enter into an experiential relation with paradox over time.

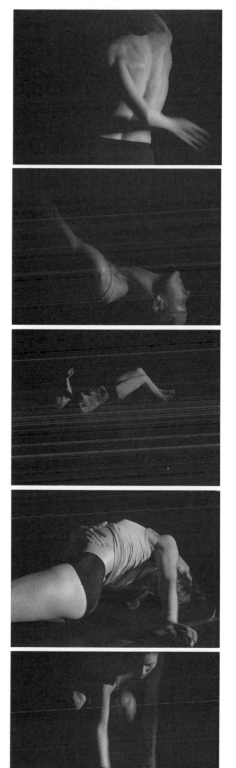

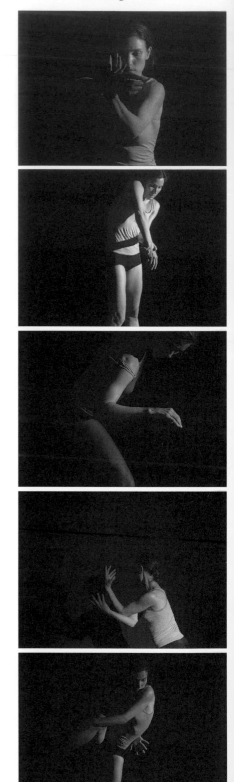

Generative Systems

SPIELMANN Does your idea of emergent meaning involve a self-reflexive process on both sides, where the activity of the viewer is somehow mirrored in the self-reflection of the medium, which through accumulation and recombining reveals structuring principles of virtual media?

SEAMAN There is a set of media elements available for exploration in each use of the work and a different meaning emergence that arises as each *vuser* recombines those media elements, so potentially each participant has a different experience of the same piece. The more time you spend with each work the more you will realise certain poetic constraints within the media elements that have been loaded into the system. I take an active role in loading certain qualities in these media elements and I do not hide a certain kind of probability for a particular range of experiences. It is not like taking anything and throwing it in and letting people recombine it. I author the variables and then the variables are explored by the participant through inter-authorship.

SPIELMANN With the montage and collage techniques as developed in twentieth-century arts we usually can clearly specify what the individual elements are and say that they have a form but the function changes in different contexts. Whereas in your virtual piece *The World Generator*, not only function and meaning of elements are changing, but also the form has a constantly shifting quality.

SEAMAN Exactly, the form itself is mutable. Each environment changes in the way that it is constructed by the participant and can shift through abstraction. There are also abstraction algorithms built into the system itself, i.e. in *The World Generator* one can highly abstract media elements. One can make a transparency or can operate with stretch or elongate the image and along with that one can apply different behaviours to the image. So what before was a still image sitting in a space, might later be rotating or abstracted. If I have ten rotating images that are intersecting they may create a dynamic new image that is emergent out of the behaviours that are being combined.

SPIELMANN It looks like montage and collage in your work are no means for tension and spectacle but rather promote a constant flow of image, music, and text. Herein, I recognise an aesthetic strategy that is mainly developed in video arts where the concern is with the continuous characteristics of electronically processed information, a notion specific to video that transgresses the idea of a coherent single unit image in favour of a constantly moving and shifting type of image. This notion of flow, also described as non-fixity and instability, seems to be even more appropriate to higher complex media such as virtual reality where the open structure refers to many different layers. I am curious to learn if and how you try to foster a sense of ambiguity when dealing with an open structure. Does it describe your concept of ambiguity to say that things are never really settled even if the order of things is fixed on a videotape?

SEAMAN I am interested in a specific ambiguity as a poetic strategy. I choose an element that would have a set of different readings, a kind of layered meaning or field. For example, you are looking at something but then a

Exchange Fields

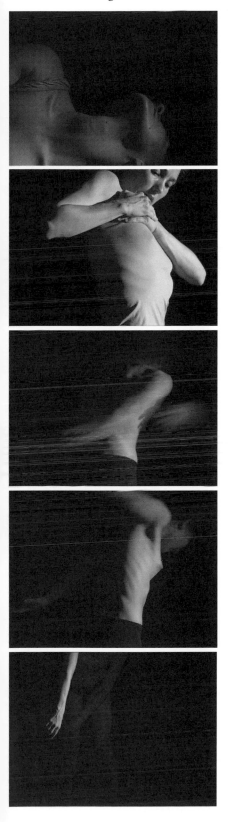

little bit later another media element makes you rethink that element. So, yes, there is a notion of relativity and unfixity of meaning that is constant in my work. But at the same time I am very careful about choosing those things that I put into the system of a work like *The World Generator* so that unfixity means a rich unfixity, namely a resonant unfixity as opposed to a chaotic unfixity. Let us say you have a pun and then you might have another pun and when you come across them they inform each other so that the overall experience of a set of media elements is greater than the sum of its parts.

SPIELMANN I am assumed that the modular system is essential to your work and I am interested in what you would define as the smallest unit of a module.

SEAMAN This becomes an interesting question because in *The World Generator* I have 3D models which are individual units, I have still images, movies, poetic lines of text and I have musical loops—all of which are individual units. When those individual units begin to be interpenetrated and fragments of images are wrapped onto objects the evocative nature of the environment can shift back and forth between an initial module and even fragments of that module. Even the tiniest fragment of a module can still be contributing to the overall evocative nature of the environment. The definition of the smallest part would essentially be based upon an individual's experience of a media element and on the level of abstraction. I would say, as soon as a media element becomes evocative and this might mean just a motion of particles or the colour of a particular part of an image . . . it is really difficult to say what is the smallest piece. It is definitely not a frame or a pixel. We might say whatever becomes evocative within the environment is the smallest piece.

Energetic Fields

SPIELMANN With your recent installation work *Exchange Fields* (Oberhausen, 2000) you seem to have further developed the concept of multiplicity into another dimension by introducing sculptural aspects.

SEAMAN Indeed, *Exchange Fields* is a very big departure. I have created thirteen pieces of furniture/sculpture and each one has a sensor built into it. When one positions different parts of one's body, for example the elbow, hands, or feet, or places the head in a certain way, this triggers a dance by Regina Van Berkel formerly of Ballet Frankfurt (Germany). There is a dynamic feedback loop between how you physically/ experientially understand the work and how the media relates to that. At the same time I am reading a poetic text and you will as well hear a sung poetic text that is talking about differing relationships between fields of energy—between people and the apparatus, in short: human-computer relations.

SPIELMANN Where would you position yourself when you think about integrating the viewer physically and spatially in a computational environment?

SEAMAN Virtual space as an authored space is very different because you have to create the things from the pixel up. And I am trying to bring my aesthetic notions into that space. So it has a particular warmth and a

The World Generator

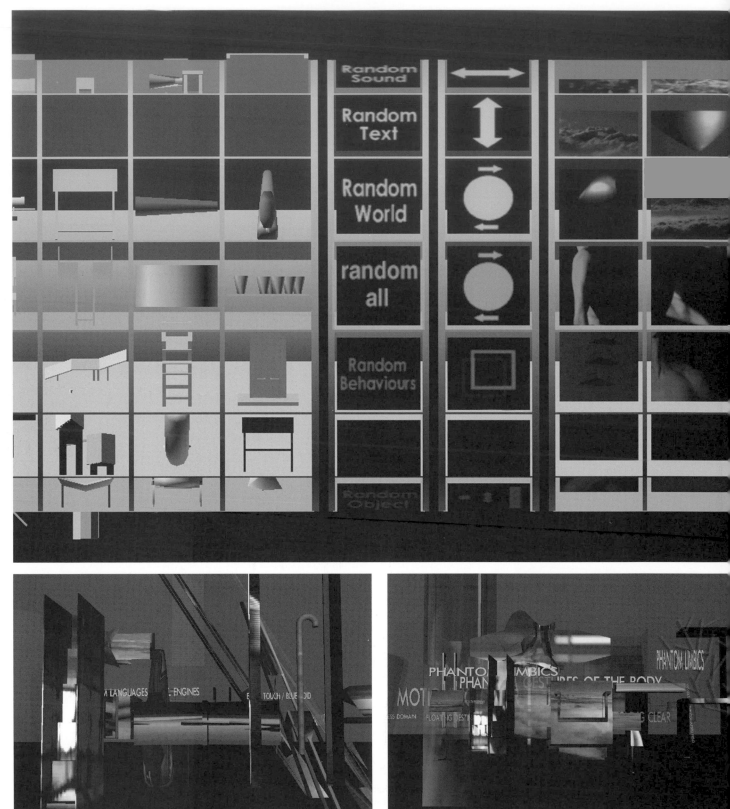

The World Generator

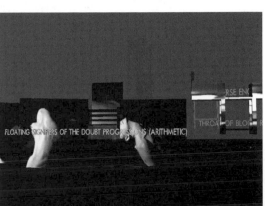

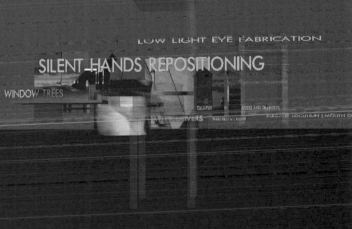

The World Generator

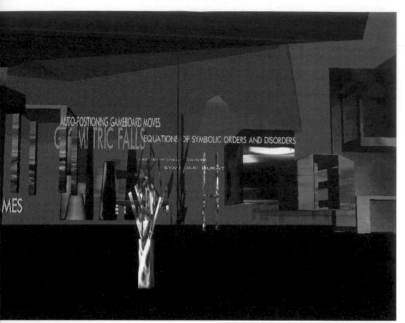

AUTO-POSITIONING GAMEBOARD MOVES
GEOMETRIC FALLS EQUATIONS OF SYMBOLIC ORDERS AND DISORDERS

SYMBOLIC DURAT

MES

LARGE AND SMALL INFINITIES OF CODE VICINITIES

RECOVERY FRAMES

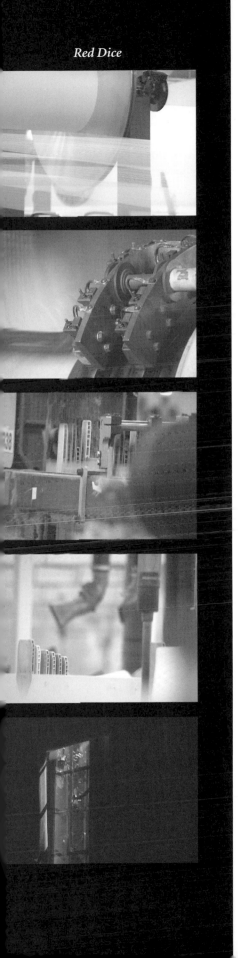

Red Dice

beauty, which is different from what we might historically think about as virtual space. I think of this space as a continuum between the environment and the participant.

Behaviour Quality

SPIELMANN Could you explain what you mean by behaviour and the shift of behavioural quality?

SEAMAN The computer more and more enables one to encode particular kinds of behaviour. Abstract physics might be manifested as a motion or form of behaviour but it might also change the scale or the volume of the sound or it might become something that literally reacts to you in a way, i.e. as if it is frightened and runs away or as if it is interested and attracted to you. Again, there is a lot of potential for different kind of behaviours in media. That is one side. We can also imagine that as Artificial Intelligence develops the participant might say a sentence and a whole media world would shift its set of relations based on how the system is programmed. For example, let us say I am interested in the computer listening for puns, and if the computer 'hears' a potential pun then it might build a media environment out of elements that are based on that pun. So here is a very different structuring notion about the potential of media

SPIELMANN I am in particular thinking of your new project with the telling title *Hybrid Invention Generator*. Could you give us an idea how the emergent, recombinant and behavioural modes will be worked out in the new piece?

SEAMAN Along with the idea of reactive media I am interested in certain kinds of encoded functionality. The new piece, *Hybrid Invention Generator*, explores the functionality of different inventions that have been historically constructed. I am authoring a conjunction code where the machine through a form of 're-embodied intelligence', looks at one invention, then looks at another invention and says: what kind of functionality do I need to make a working bridge between these two inventions.

SPIELMANN Can you name machines that will be combined in the *Hybrid Invention Generator*?

SEAMAN In *Hybrid Invention Generator* I might take a computer-based process and a machine that has a spinning wheel. The computer would say: what do I need to translate the computer code and make it talk to and control a spinning wheel? The computer will need to find those parts and will visualise them resulting in a new entity that might be called 'computerwheel'. The user of the system can then abbreviate that term through another algorithm ending up with a new name for the hybrid device—'compuwheel'. What I am working on now is the hardest part, because, literally, I must define what the functionality is and how I can isolate particular functions—for example a car has five hundred inventions and not just one. So I am working on how to find the salient translation or connecting mode. In fact, I have decided to list many choices for the *vuser* and let them decide through interactivity. It could be that it is about the physics of the thing that generates heat or that it is about how one code talks to another code to make something work.

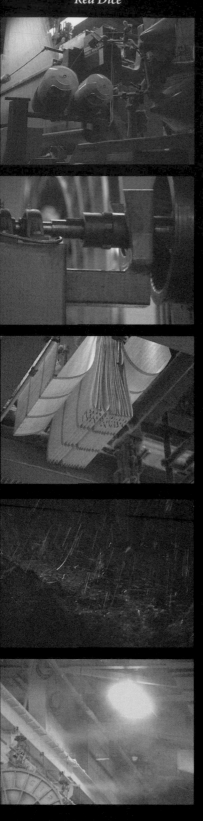

I could choose something, which is about being large, and shrink it down to a nano size. In the end I have used a black box model: input + functionality = output, where the output of one device must potentially go through some form of translation to become the input of the other device. In the long run this seeks to be a universal system.

SPIELMANN As an artist you are really going into the machine structure itself, and there it seems that a new step needs to be taken in the computer machine age.

SEAMAN We can begin to talk about the genetics of machines, because if we think of the recombinant poetics in the earlier piece, *The World Generator*, in the new piece I am really taking things one step further in literally developing a poetics of hybrid functionality. There is a large history of different kinds of inventions and I am expecting to derive many new hybrid forms of devices—absurd machines, mechanic monsters and funny mechanisms as well as other interesting functional hybrids, through interaction. As we encode computers so that they can learn, eventually they may take on a kind of autonomy. It may be that computers develop something like a consciousness of their own—but this will be some years in the future. In terms of authoring new media in my work *Hybrid Invention Generator*, we might say that there is a 're-embodied intelligence' that enables the work to become functional— where I am investing much energy in loading operative key words and developing intelligent 'conjunction codes' to become operative within the system. In turn this 're-embodied intelligence' derives a form of computer-based intelligent functionality. I certainly explore aesthetic strategies but I work with them in such a way that the computer itself can generate something based on those strategies through chance processes or a *vuser* can derive new devices through dynamic interaction. We are facing a new horizon of generative media relations. And yes, I am really trying to get to the level of making new programs and thus pushing the potentials of what the media can do. I am very interested in exploring what our relationship with media might become through interaction with these differing kinds of generative systems.

Location: http://www.circusweb.org/board/index.php

Back | Forward | Reload | Home | Search | Netscape | Images | Print | Security | Shop | Stop

Circus Message Board - post a message | FAQ

- fd +++++ ++--+m+mmmmmm+,,,,, m++--+mm,,,m- mm-++++++++++
 ++++++ +--mmmm+mmmm+mmmm+ ++-++++++m--,,,m- ++mmmmmmmmm
 +++-++mm,,,m- mm-++++++++++ +++++++--++++m m, - 2001-07-31 2:41:58am

- t/css"> a { text-decoration:none;} div { font-family:Verdana;} td { font-family:Verdana;} </style> </head> <body bgcolor="white"> <div
 align="left"> Circus Messa <div align="left"> <di - 2001-07-31 2:37:29am - LLLLLLLLLLrma -
 2001-07-04 9:14:00pm WL - 2001-07-31 2:41:29am

- 5pm sitPost a Xv Xv mes fd e ttil dedivo ? rJ n mi .F nhoJ dna reipaN Xv fd e ttil dedivo ? rJ n mi .F nhoJ dna reipaN s - itle> us Mes Bo e> <sty
 type="text/css"> a { text-decoration:none;} div { font-family:Verdana;} td { font-family:Verdana;} </style> </head> <body
 bgcolor="white"> <div align="left"> Circus Messa <div align="left"> <di - 2001-07-31 2:37:29am

- \|==yuio====00 ===0============0 - 2001-07-31 2:31:39am

- e:e:
- sit$%^~\@#$%^&*()__ ++_)(*&^%$-----</u</ul@#$%^&*()__ ++_)(*&
 - e:
- sit$%^~\@#$%^&*()__ ++_)(*&^%$-----</u</ul@#$%^&*()__ ++_)(*
 - 2001-07-31 2:28:11am

- sit$%^~\@#$%^&*()__ ++_)(*&^%$-----</usit$%^~\@#$%^&*()__ ++_)(*&
- Mge ard - post a mess---- | FA Mge ard - post a mess---- | FA - 2001-07-31 2:20:30am
- Mge ard - post a mess---- | FAQ
 Ch@Cha
 --hu! - Ju - 2001-07-29 8:51:31pm res - 2:25:36pm 07-02 2:0======0 0======0 0======0
 0======0 0======0 0======0 0======0 0======0
 0======0 0======0 0======0 0======0
- Ch@Cha----------LLLLLLLLLLLLLLLLLLLLLLLLLLLLLLLLLLLLLL
 --hu! - Ju - 2001-07-29 8:51:31pm research proposal - Doron Furman - 2001-07-04 9:14:00pm Wow - great site! - Adam - 2001-07-02
 2:27:25pm Media rich websites - John Patterson - 2001-07-02 2:26:55pm site - Tim Putnam - 2001-07-31 2:15:49am

- u-hu! - Ju - 2001-07-29 8:51:31pm
- research proposal - Doron Furman - 2001-07-29 8:51:31pm
 - o Re: rese sal - LLL)JL)JL))JL)JL - 2001-07-31 2:18:20am
- Ch@Cha-------------------LLLLLLLLLLLLLLLLLLLLLLLLLLLLLL

- Wow - great site! - **Adam** - 2001-07-02 2:27:25pm
- Media rich websites - **John Patterson** - 2001-07-02 2:26:55pm

Back | Forward | Reload | Home | Search | Netscape | Images | Print | Security | Shop | Stop

Location: http://www.circusweb.org/board/index.php?action=view&id=19

thread tree:

- **fd** +++++++ +--+m+mmmmmmmmmmmmmmmmmmmmmmmmmmmmm+,,,,,, m++--+mm,,,,m--nm-++++++++++
 +++++++++mmmmmmmmmmm+mmmmm-,,,,, +++-+-++m--,-m- ++mmmmmmmmm
 +++++--+mmmm+mmmmm+mmmmm,,,,,, ++-++++mmm,,m,-**fd** +++++++-++m+mmmmmmmmm+,,,,,,
 m++--+mm,,,,m--mm-++++++++++ +++++-++m+mmmmmmmmmmmmmmmmmmmmm+,,,,,,
 ++++-+mm,,,,mmmm+mmmmmm+mmmmm,,,,,,, m, -2001-07-31 2:41:58am

Add A Reply:

name:

email:

subject: Re:

Back Forward Reload Home Search Netscape Images Print Security Shop Stop

Location: http://www.circusweb.org/board/index.php?action=view&id=19

Back Forward Reload Home Search Netscape Images Print Security Shop Stop

Location: http://www.circusweb.org/board/index.php?action=view&id=19

fd

Posted by fd +++++++--+m+mmmmmmmmmmmm+,,,,,,,, m++--+mm,,,,,m-
,,,,,,,, ++-++++m---,-m- ++mmmmmmmmmmm,,,,,,,, ++-+++ +mmm,,m,
,,,,,,,, ++-++++mmm,,,,,, m++-++mm,,,,,m- mm-++++++++++ on 2001-07-31 2:41:58am

fd

Post a reply | View replie
Back to Circus Mess
Bo

Netscape: Circus Message Board

Back | Forward | Reload | Home | Search | Netscape | Images | Print | Security | Shop | Stop

Location: http://www.circusweb.org/board/index.php?action=view&id=17

wwwwhhhhnw+vwesssr ,,+vrr+vseenmeesenwwwrsss+ssssrvv+vseenw
nmwmwhhhhs wesss+ ,+ehwwer++ssvvwvrrssrv++verrrrnssrrvvsnnnw
sewwwhhhhev, +essssr+, +swwwrvvrss+nnr,ssseeeenrnrnessrrvvrvvrrsvw w
ssrrseww sw,, sessssr++ rrwevrsssse+ss,rsssseeernnnmwestrvv+vvrrsenes
vrssnnwwenr , wessssrrv+, swwennnmv+ssssssevee,rssssseernnnwmeeeesrrrrssennsen
+rrsssennr+vv++mwessssrrrvvsehhhhhmwwwnessvrne,rsssseeenmnwwestrssssssssennsrrs
+resrvvsv+ennnrnnmmnhwessssrrrvwhhhhww+wtnhhhwwnvnmn+nnwwwwesrrvrsssssssseeenwmnwwh
55pm s======================i=====tpm sit Xv Xv 55pm wh
s======================itpm sit Xv Xv 55pm si=========================tpm sit Xv Xv 55pm
Xv Xv 5============================5pm sitpm sit Xv Xv Xv Xv Xv X Xv Xv Xv X5pm sitpm s
Xv Xv Xv Xv Xv Xv Xv Xv Xv Xv Xv Xv Xv Xv X Xv Xv Xv Xv Xv X5pm sitv X
Xv Xv
Xv Xv
Xv Xv
Xv Xv
Xv Xv
Xv Xv

thread tree:

- **5pm sitPost a Xv Xv mes fd e ttil dedivo ? rJ n mi .F nhoJ dna reipaN Xv fd e ttil dedivo ? rJ n mi .F nhoJ dna reipaN s - itle> us Mes Bo e> <sty**
 type="text/css"> a { text-decoration:none;} div { font-family:Verdana;} div { font-family:Verdana; } td { font-family:Verdana; } </style> </head> <body
 bgcolor="white"> <div align="left"> Circus Messa <div align="left"> <di - 2001-07-31 2:37:29am

Add A Reply:

name:

email:

subject: Re: 5pm sitPost a

message:

Xv		Xv	Xv	Xv	Xv	Xv
Xv	v	Xv	Xv	Xv	Xv	Xv
Xv		Xv	Xv	Xv	Xv	Xv
Xv	Xv	Xv	Xv	Xv	Xv	Xv
Xv	Xv	Xv	Xv	Xv	Xv	Xv
Xv	Xv	Xv	Xv	Xv	Xv	Xv
Xv	Xv	Xv	Xv	Xv	Xv	Xv

Submit Query

Back Forward Reload Home Search Netscape Images Print Security Shop Stop

Location: http://www.circusweb.org/board/index.php

Circus Message Board - post a message | FAQ

- e:e:
 sit$%^~!@#$%^&*()___++_)(*&^%$-----</u</u!@#$%^~!@#$%^&*()___++_)
- sit$%^~!@#$%^&*()___++_)(*&^%$-----</u</u!@#$%^~!@#$%^&*()___++_
 sit$%^~!@#$%^&*()___++_)(*&^%$-----</u</u!@#$%^~!@#$%^&*()___++_
 - 2001-07-31 2:28:11am
- Mge ard - post a mess---- | FA Mge ard - post a mess---- | FA - 2001-07-31 2:26:41am
- Ch@Cha------
 --hu! - Ju - 2001-07-29 8:51:31pm res - 2:25:36pm 07-02 2: 0===
- u-hu! - Ju - 2001-07-29 8:51:31pm
- research proposal - Doron Furman - 2001-07-29 8:51:31pm
 o Re: rese sal - LLL)L))L))LL))L))L) - 2001-07-31 2:18:20am
- Wow - great site! - Adam - 2001-07-02 2:27:25pm
- Media rich websites - John Patterson - 2001-07-02 2:26:55pm
- site - Tim Putnam - 2001-07-02 2:26:17pm
 o Re:
 sit$%^~!@#$%^&*()___++_)(*&^%$-----</u</u!@#$%^~!@#$%^&*()___++_)(*&^%$-----</u</u</u!@#$%^~!@#$%^&*()___
 - +++&&Post a ost a rep repreost a rep repp reost a rep reppost a rep rep s | Back to Circus Message Board && - 2001-07-31 2:25:16am
- FROM DE DIRECTORS DESK - Raul Marroquin - 2001-07-02 2:25:16am

Post a message:

name:

email:

subject:

message:

Netscape: Circus Message Board

Back | Forward | Reload | Home | Search | Netscape | Images | Print | Security | Shop | Stop

Location: http://www.circusweb.org/board/index.php

Circus Message Board - post a message | FAQ

- e:e:
- sit$%^~!@#$%^&*()__ ++_)(*&^%$------</u</u</u</u</u></u>
 - e:
 sit$%^~!@#$%^&*()__ ++_)(*&^%$----------</u</u</u</u</u></u><
 - 2001-07-31 2:28:11am
- sit$%^~!@#$%^&*()__ ++_)(*&^%$----------</u</ui@#$%^~!@#$%^&*()__ ++_)(*&^
- Mge ard - post a mess---- | FA Mge ard - post a mess---- | FA - 2001-07-31 2:26:41am
- Mge ard - post a mess---- | FAQ
 Ch@Cha-------------------------------------LLLLLLLLLLLLLLLLLLLLLLLLLLLLL
 --hu! - Ju - 2001-07-29 8:51:31pm res - 2:25:36pm 07-02 2: 0=========0 0=======0 0=======0
 0========0 0==========0 0===========0 0====== - 2001-07-31 2:20:30am
 0=======0 0========0 0==== - 2001-07-31 2:20:30am
- Ch@Cha--LLLLLLLLLLLLLLLLLLLLLLLLLLL
 --hu! - Ju - 2001-07-29 8:51:31pm Media rich websites - John Patterson - 2001-07-02 2:26:55pm site - Tim Putnam - 2001-07-31 2:15:49am
 2:27:25pm Media rich websites - John Patterson - 2001-07-02 2:26:55pm site - Tim Putnam - 2001-07-31 2:15:49am
- u-hu! - Ju - 2001-07-29 8:51:31pm
- research proposal - Doron Furman - 2001-07-04 9:14:00pm
 - Re: rese sal - LLL)L)))L)L)))L))L) - 2001-07-31 2:18:20am
- Wow - great site! - Adam - 2001-07-02 2:27:25pm
- Media rich websites - John Patterson - 2001-07-02 2:26:55pm
- site - Tim Putnam - 2001-07-02 2:26:17pm
 - Re:
 sit$%^~!@#$%^&*()__ ++_)(*&^%$----------</u</ui@#$%^~!@#$%^&*()__ ++_)(*&^
 - +++&Post a ost a rep repreost a rep repp reost a rep reppost a rep rep s | Back to Circus Message Board && - 2001-07-31 2:25:16am
- FROM DE DIRECTORS DESK - Raul Marroquin - 2001-07-02 2:25:36pm

Post a message:

name: [0=======0 0=======:]

email: [0=======0 0=======:]

subject: [|0=======0 0=======:]

message:
```
2001-07-31  2:20:30am
      Ch@Cha------------------
LLLLLLLLLLLLLLLLLLLLLLLLLL
LLLLLLLLLLLLLLLLLLLLLLLLL
LLLLLLLLLLLLLLLLLLLL------
LLLLLLLLLLLLLLLLLLLLLLLLLL
LLLLLLLLLLLLLLLLLLLLLLLLL
i-LLLLLLLLLLLLLLLiiii
     hu! - Ju - 2001-07-29 8:51:31pm
```

Back | Forward | Reload | Home | Search | Netscape | Images | Print | Security | Shop | Stop

Location: http://www.circusweb.org/board/index.php?action=view&id=8

Ch@Cha--LLLLLLLLLLLLLLLLLLLLL------------------------LL

Posted by -hu!- Ju - 2001-07-29 8:51:31pm research proposal - Doron Furman - 2001-07-04 9:14:00pm Wow - great site! - Adam - 2001-07-02 2:27:25pm Media ric
websites - John Patterson - 2001-07-02 2:26:55pm site - Tim Putnam - 2001-07-02 2:2 on 2001-07-31 2:15:49am

http://-hu!- Ju - 2001-07-29 8:51:31pm
research proposal - Doron Furman -
2001-0LLLLLLLL)))LL)))LLLL)L)L)L)L===----C*---\CLCLLLLLLL)))LL)))LLL)L)L==CLCLLLLLLL)))LL)))LL)LI
thod=POPutn----nt-fa--:[O]{)M]I)-\]----------[O]{)M]I)-\]----------</u\0[{)M]I)-\]-------------</u\0[{)M]I)-\
]------------</u\0[{)M]I)-\]---------------</u\0[{)M]I)-\]
]------------</u\0[{)M]I)-\]---------------</u\0[{)M]INIP]88~!@#$%^&*()_\-\
QWERTYUIZYTREWQ---------------------------------</u-</ul@#$%~!@#$%^&*()_++_)(*&^%$-----------</u-</ul@#$%~!@#$
ZQWRFTGYHUJZGFDSASDZFGHJKLZJHGFZGHJKL.ZLKJHGFZGHJKL.ZKJHGFDSZDFGHJKL.ZKJHGFDSAZDFGHJKLZKJHZXCVBNM

C*---\L))))LLL)))LL)LL)L)L)L)L)L===----C*---\L)))LL)))LLL)L)L===----C*---\L)))LL)))LL)LL)L)L)L)L)L===-\L)))LL)LL)L)L
CLCLLLLLLL)))LL)))LLL)L)L==CLCLLLLLLL)))LL)))LL)LL)L)L)L)L)L==\L)))LL)))LL)LL)L)L)L)L)L===-\L))LL)L)L
LLLLLLLL)))LL)))LLL)L)L)L)L)L)L[[][[][][] [][][][][][][] [][][][][][][][[][][][][][] [][][][][][][]
[[][[][][][] thread tree:0o-0oardircusMes- po-0oa-0oard--\]rd - post a mess--\]rd - post a mess-\L)))LL)))LL)LL)L)L)L)L)L))LL)LL)L)L
ss----\]d - p-0rd - ss----\]d - p-0 rd - ss----\]t a-0oard - prard vast a mrard vaess--\]o-0oard -rd - ss----\]s-0rd - ss----\]d -
p-0oard - porard vast a mess----\]d - p-0oard - prard vast a mrard vaess--\]o-0oard -rd - ss----\]d - p-0 post amess--\]s-0rd - ss----\]d
post a mess---\- Cc:ds.nl/main.phnt-fap3 -2001-07-08 9:39:00amRe: -0o-0oardircusMes- po-0oa-0oard - rd - ss----\]d-p-0ost a mess---\]t a-0oard - porard vast.
merard vass-- aE
DIge:</ - 2001-07-08 9:41:47am
Re: e: -0o-0oardircusMes- po-0oa-0oard-p@po wwwwww+++++++wwwwww - Ch#@3456 - 2001-07-08 9:56:19am
LLLLLLL)))LL)))LLL)L)L)L)L)L)L===C*---\L)))LL)LL)L)L)L)L)L==-C*---\L)))LL)))LL)LL)L)L)L)L)L===-C*---\L)))L

C*---\L)))LLL)))LL)L)L)L)L)L===CLCLLLLLLL)))LL)))LLL
L)LL)L))L)L==)L)))LL)LL)L)L)L)L)L===C*---\L)))LL)LL)L
[[][[][][] [][][][][][][] DIlignt-faE DIn="E DI left">PoE Dist E DI a mesE E DI IsaE DIge:<for thod=PO Putn----nt-fa-\]---------[O]{)M]I)-\]
[[][[][][] [][][][][][][] DIlignt-faE DIn="E DIleft">PoE Dist E DI a mesE E DI IsaE DIge:<for thod=PO Putn----nt-fa---------</u\0[{)M]I)-\]
DIlignt-faE DIlignt-faE Din="E DIleft">PoE Dist E DI aE DIlignt-faE Din="E DI left"><dE DIiv E E DI DI DI aE
DIn="E DI left">PoE Dist E DI a mesE E DI IsaE DIge:<for thod=PO Putn----nt-fa-------</div>
<a na
st"><dE DIiv E E DI DI DI aE DIlignt-faE DIn="E DIleft">PoE Dist E DI a mesE E DI IsaE DIge:<for thod=PO na st"><dE DIiv E E DI DI DI aE
QWERTYUIZYTREWQ-----------------------------------</u\0[{)M]I)-\]---------------</u\0[{)M]I)-\]
ZQWRFTGYHUJZGFDSAZDFGHJKLZJHGFZGHJKL.ZLKJHGFZGHJKL."ZKJHGFDSZDFGHJKL.ZKJHGFDSAZDFGHJKLZKJHZXCVBNM

LLLLLL)))LL)))LLL)L)L)L)L)L)L===-L))))LL)LL)L)L)L)L)L=={-\L))L)L)L)L)L)L))LL)LL)L)L)L)L)L==CLCLLLLLLL)))LL)))LLLLLL)L)L)L)L===-L

Back | Forward | Reload | Home | Search | Netscape | Images | Print | Security | Shop | Stop

Location: http://www.circusweb.org/board/index.php?action=view&id=10

Mge ard - post a mess---- | FAQ
Ch@Cha-
--hu! - Ju - 2001-07-29 8:51:31pm res

Posted by 2:25:36pm 07-02 2: on 2001-07-31 2:20:30am

Back Forward Reload Home Search Netscape Images Print Security Shop Stop

Location: http://www.circusweb.org/board/index.php?action=view&id=10

thread tree:

6pm
2:25:36pm
-07-02 2:25:36pm
-07-02 2:25:36pm
-07-02 2:25:36pm
-07-02 2:25:36pm
-07-02 2:25:36pm 07-02 2:25:36pm

- **Mge ard - post a mess---- | FAQ**
 Ch@Cha-----
 - -hu! Ju - 2001-07-29 8:51:31pm res - 2:25:36pm 07-02 2:0
 - 2001-07-31 2:20:30am

So everything joyful
is mobile . . .

Matt Locke, Matthew Chalmers & Francis McKee
in conversation with
Simon Yuill

MATT LOCKE

Creative Director of BBC Imagineering
London, England, UK

Born 1972 in UK

Lives and works in London

MATTHEW CHALMERS

Senior Researcher
Department of Computer Science,
University of Glasgow, Scotland, UK

Born 1963 in UK

Lives and works in Glasgow

FRANCIS MCKEE

Head of Digital Arts & New Media
CCA, Glasgow, Scotland, UK

Born 1960 in Northern Ireland, UK

Lives and works in Glasgow

So everything joyful is mobile . . . [1]

Discussion with MATT LOCKE, Creative Director of BBC Imagineering, the BBC's future technologies research unit, and previously Director of The Media Centre, Huddersfield, where he supported various critical and creative projects based around mobile systems such as text messaging. Joined by MATTHEW CHALMERS, Researcher in the Department of Computing Sciences, University of Glasgow, and FRANCIS MCKEE, New Media Curator of Glasgow's CCA Gallery. The discussion was initiated and hosted by SIMON YUILL, Glasgow, 17 August 2001.

Preamble

The rapid spread of mobile technologies, from mobile phones to Personal Data Assistants (PDAs) has impacted on our experience of space, merging our real physical spatial activity with electronic data and communication spaces. This 'augmented reality'[2] is based around a different paradigm from that of the Virtual Reality (VR), that was talked about in the early 1990s. Rather than an escape from the fleshy world into one of pure data promoted by VR enthusiasts and cyberpunk fiction, the augmented reality of mobile cultures collides the virtual and the real, the empirical and the informational.

Characteristic of the cultures and habits that are emerging around mobile devices are transitory links that transcend and transgress the limits of physical space in order, perhaps paradoxically, to re-enforce a sense of *location* as the 'place' defined by what I am doing and who I am with, even though position, activity and people may be entirely disconnected semantically and physically.

MATTHEW CHALMERS Pretty soon someone will be able to walk into a museum and have their own guide, and their own way of going round the exhibition, or whatever it is, completely ignoring all the signage and their design. In that space they will be able to leave things for other people. People will be able to add things to that space, altering what other users will find there. Such an addition might be a comment on an exhibit or a caricature of an eighteenth-century painting, etc. Even though other users will find them through electronic media, they are nonetheless present in that space, floating in their field of vision, and there is nothing the curator can do about it.

FRANCIS MCKEE I like that idea. It offers a promise of democracy different from the one held up by the Internet. It probably is not real either, but allows other people to get involved.

CHALMERS Such strategies are certainly susceptible to trend and market. Yet there is something else with much more dynamism involved. It is

1. Walter Benjamin, 'Naples', in: *One-Way Street and Other Writings*, trans. by Edmond Jephcott and Kingsley Shorter, London and New York, Verso, p.171.

2. The term 'augmented reality' was coined by Mark Weiser, see his article 'The Computer for the 21st century', in: *Scientific American Special Issue*, 1995.

enabling cultural and social participation in places where it was not possible before. It is something that until recently has been mainly available for website managers. Now it is at the disposal of curators and artists. You can expect anything you do to be defaced, ripped apart and re-made to a much greater extent than before. Within minutes of creating it, of publishing it on the Internet or elsewhere, some crawler trawling the web is going to pick it up and trash it or comment on it. Such behaviour will just become mundane.

MCKEE We are experiencing an interesting moment in time that will get closed down someday. In fact, there already is a whole movement that is trying to bring that moment to an end. In the old days at MIT (Massachusetts Institute of Technology, USA) students were taught to burgle. You would get a lock picker guide when you went, and would be taught how to break into MIT, so that you could walk around all the spaces you were not meant to have access to. That was taught as a hacker technique too, transferred to the Internet.

MATT LOCKE There is an issue in massively distributed networks of that kind you have just described, that seems to embody democracy and yet comes back to the signal and noise aspect. Although technology makes more things possible, the users tend to be or remain more conservative. So you start to look at the applications of technology from the user's point of view. When people enter an anarchic content space they pretty quickly tend to want some kind of sense of what is good and bad there. Similarly, the challenge for mediators—whether they are placed in a gallery or with a publishing company or a TV channel—lies not in the evasion of their content becoming part of this distributed environment, but to recognise and own patterns of behaviour, to almost recognise, utilise and / or shape centres of gravity in massively distributed environments. They can start to feed preferable patterns of behaviour more than those they do not want to encourage or approve of.

CHALMERS What happens if the big weight of the centre of gravity points towards something they do not approve of?

SIMON YUILL That points towards advertising picking up on counter cultures . . . the challenge becomes desirable. You allow things to be hacked or broken into. You encourage such subversiveness because you can tap into them.

CHALMERS Assuming you can control that to some extent . . .

LOCKE That is the problem. Whether you have that control or not, is a philosophical question for the organisation. At a conference recently, Ceila Pierce, an interaction designer based in California, talked about the games market, games culture, and compared them to the music sector. She said *Napster*[3] created a massive opportunity to tap into people's social patterns within the music industry and compared that to games culture. *Counter-Strike,*[4] which essentially is a hack of *Half-Life,*[5] was awarded as best online game by the games industry itself. In other words, the games industry recognised that *Counter-Strike* was a good example of that kind of hacking of official content. *Counter-Strike* produced a huge centre of gravity. The games industry acknowledged its innovative potential and quality. This specific network culture recognised the value of such activity.

3. Napster, see http://www.counter-strike.net
Napster is a piece of software enabling people to freely exchange collections of MPEG audio files. Whilst many musicians have supported its use as it reinforces fan communities, the music industry came down heavily on the developers of the software, with the result that, at the time of writing, the service is being closed down.

4. *Counter-Strike*, see http://www.counter-strike.net

5. *Half-Life*, see http://www.sierrastudios.com/games/half-life

MCKEE We will see more of such developments now.

LOCKE It is a big issue for organisations that cannot be as adept as the games industry, where the people working in and for it are completely coded in the culture of hacking. The bosses of games companies come from that environment. Organisations, who have evolved outside such a counter cultural context, are faced with the pressing issue of how do you deal with counter cultural environments, how do you deal with their dynamic.

MCKEE The Internet is a promiscuous medium in every form.

LOCKE It is interesting to look at *Rhizome*[6] because they are good at creating that centre of gravity themselves. They create a role for themselves as mediators. Steven Johnson, who wrote *Interface Culture*[7] and used to run *feedmag.com*, is just about to publish a new book called *Emergence*. One of the chapters is very much on these themes: how do these centres of gravity of patterns emerge from networks? What kind of tactics does one use to engage and utilise them as mediator or creator, or whatever? One of the chapters is a brilliant analysis of *Slashdot*.[8] The designers of *Slashdot* created a rating system, which allows users to set their level of engagement with the huge noise that goes on in the space. Also, rather than having a fixed moderator, they developed the idea that the community are the moderators themselves. Editing and moderating such a mailing list is a very time-consuming and expensive task. Its content is constantly recycled. By involving the community *Slashdot* has achieved a very strong position. The community is in control of *Slashdot* as an entity, even though they do not directly control its parameters. A structure has been developed that enables the *Slashdot* community to operate very efficiently without building strong walls around them. They have created a very flexible architecture behind the whole community, which is, in a sense, a form of curation that does not seem to be very exclusive.

MCKEE That seems also similar to *bloggers*.[9] Everyone can become their own curator. Everyone can say 'these are the sites I recommend'. Yet, there is a certain conservatism in the way people select and rate those sites. The most popular sites feel slightly conservative because they are more content based. *Bloggers* have their own set agendas and tastes. They act as curators and direct other users towards various things and issues. Suddenly we are faced with a whole new curating culture. Everyone is a curator, in fact those bloggers are often more interesting than curators.

LOCKE There are strong elements of similarity between the blogging scene and the *Barbelith Network*[10] and related distribution structures, which resemble conglomerates of bloggers based to a large extent on social patterns.

CHALMERS I am making a sweeping generalisation here, but most people in computer science departments do not know much about bloggers and similar scenes. They are not too familiar with the whole world and attitude concerning the use of the web. These developers of technologies do not pay much attention to the web. They see it as a source of documentation. Their work is much more concerned with context-aware systems, mobile and wireless technologies.

LOCKE It is funny that you mention context awareness, because that could

6. *Rhizome*, see http://www.rhizome.org, is a mailing list and web site focusing on net-based art and related critical issues.

7. Steve Johnson, *Interface Culture:* How New technology Transforms the Way We Create and Communicate, New York, HarperCollins Publisher, 1997.

8. *Slashdot*, see http://slashdot.org, a web site and online community that collects and discusses news articles broadly relating to programming and hacker culture.

9. Bloggers, see http://www.blogger.com

10. *Barbelith Network*, see http://www.barbelith.com

mean something very much like we just talked about.

CHALMERS It could be, but not on the web as such. The web is almost immaterial. It is not that important any more, or it is taken for granted. Right now, systems that know where one is physically, what one is doing, who one is with, are of interest. It could be electronic information one has been using or the food one has just eaten, or the picture on the wall one was just looking at. All of these things could be as important where one has been on the web, the trails one has left looking through somebody's website.

LOCKE That is quite an important distinction. Look at the work of Fiona Raby.[11] She is interested in the difference between location and position. Position is an abstract point, it is your electronic trail in an abstract network, or it may be the radio mast you are closest to and how that information—you are in the CCA or outside a particular shop—can be mapped in relation to any other information available. Raby's work is not so much concerned with the conceptualisation of the user as a point in the landscape, but investigates pattern and behaviour. We were asked to make a presentation to Hutchison G3, one of the new companies who are going to launch broadband wireless. I talked about the way in which we try to predict the context for a user who we know we cannot predict a context for. The user may be sitting at a desk, at home or at work or in a gallery looking at a monitor; or we do not have an idea about the user context at all. That is, we do not have context awareness. At the moment, we do not have advanced enough technology; therefore we use very old methods like time. Or we attempt to create a context and we target the website by using proper flyers.

CHALMERS Did Hutchison G3 not offer to give you all the positioning information they keep . . . ?

LOCKE We are less interested in this information per se. Of greater importance to us is the location of the user, their sense of identity. For example, we did a number of projects with Rachel Baker[12] based around Hull City Football Club working with the local fanzine. The local fanzine is a great way to distribute information to our market group. We did not need to know where they were or who they were. They bought the fanzine because of their interest in football. That provided us with an easy context to tap into. I am interested in the way we tap into existing distributed networks outside of technology to motivate people to use the technology in that way. We put up posters outside pubs near the football ground. That way one can build up attitudes and patterns of behaviour from the bottom to the top rather than in a top-down fashion. The Head of Location Based Services at Hutchison completely refuted our approach by saying: 'we will be able to know that there are three people driving up the A1 and they slowed down this morning because everybody else stuck in a traffic jam'. His idea was to get to a place that made it possible to look down from above and to use it as a point on an abstract network. Afterwards I found out that he is an ex-SAS man, so I can imagine him mapping an abstract point as a target . . .

CHALMERS He was going to fire missiles at them!

LOCKE Positioning to him meant something extremely strong and of far greater importance than linking it to any social sense.

11. Fiona Raby, see http://www.crd.ac.uk/dunne-raby

12. Rachel Baker, see http://www.irational.org/rachel

CHALMERS One could do a lot with phones. If they were kept on all the time one could get an idea about ongoing conversations. Many people are interested in this area in terms of technology, yet in order to make progress a lot of trust and creative work is necessary. There are already a lot of research groups who work with artists and theatre groups in order to find possibilities for opening up this territory. Slowly, computer sciences begin to appreciate that technology is not just for work and business.

LOCKE I am quite interested in notions of AI (Artificial Intelligence), agents and bots,[13] and whether by mapping trails people leave when using the web for instance you can produce something that is really useful to the user or if it is easier to try and set up serendipitous moments for the user to come across themselves.

MCKEE I like the notion of serendipity, because when you talked about the ex-SAS man's view of location I thought of James Joyce's *Ulysses*: you might be at a funeral but you think about a football match; or you are at a football match but think about someone's funeral, that is, your location does not necessarily specify your thoughts. You might think funeral, then party and then the new Prince album comes to mind followed by football. It will all be associative in the same moment, the same series of moments in the one location. The serendipitous moment is the really exciting possibility, the associative one.

CHALMERS That is the great weakness of AI and of all the bots. I do not rate that line of enquiry at all. It is based on a kind of agency, the assumption that you can do this stuff by those external signs and patterns of behaviour. Obviously, AI, bots and this kind of technology enable people to do many rather mundane things. However, I prefer working towards agency as an extension of what you do yourself, i.e. driven by the individual, rather than developing an agent that works autonomously. An agent, however developed, can never match and keep up with the complexity of the user's thoughts when there are no external cues to follow, unless it is being steered all the time, although it might be—to some extent—able to guess one's intentions.

LOCKE In that way, mobile work is really interesting, because you can learn from the cities. Cities are accretions of patterns of behaviours accumulated over years. In a commercial sense, things like billboard designs and the location of billboards within the urban space map people's behaviour in a network. Such a positioning according to types of demographics is absolutely clinical. Most people who live in a city have developed very specific patterns of behaviour. The city has a vocabulary and infrastructure, which we are all aware of. I am interested in the difference between trying to guess the profile of an individual user or basing information on a pattern of social behaviour. The latter strategy builds on architecture and urban design. Vast amounts of information held by town planners are based on recognised behaviour. Regarding serendipity, of course, I do not know what one person might need right now, but if I were to leave a certain message in a certain location for a period of time, a number of people might walk past and some of them might be interested in that message because it is near a football ground or outside a school. This strategy compares to a kind of hyper-

13. Bots are pieces of software that run autonomously, usually doing tasks such as searching the internet in order to map page content for search engines. One of the best-known bot-based search engines is located at http://www.hotbot.com.

personalisation based on: 'I know what you are going to need in five minute's time.' I am interested to see which strategy is the more valuable one.

MCKEE There is another important tradition of the late nineteenth and all through the twentieth century: the *flâneur* moving through the city, looking at it and taking it from a different point of view.

LOCKE Lucy Kimbell held a conference at UCL (University College London) recently about the *flâneur* and mobile technologies. *Cellularflanery,* I think, it was called. We started to think and write about those patterns of behaviour. I gave a presentation at Banff on what I called 'Commuters, Tourists, Gangs and Fans', in order to crudely describe four ways in which people move through the urban space. Commuters navigate the city in extremely fixed patterns. Any distraction, for instance a SMS message advertising a discount on disk drives for instance, would probably be ignored in the hurry to get to and from the workplace. Commuters will only want information that reinforces their patterns and enables them to get faster or easier from A to B. A tourist or *flâneur*, however, is completely open to information about the place, its facilities, special shopping and entertainment opportunities, the unexpected, etc. Fans and gangs to me describe mass movement of people around the city. Fans are people predicated towards attending a specific event. A visible sense of community develops, as one gets closer to its location. And so do one's content-related interests. Gangs are marked by a far greater level of dynamics. I am fascinated by the way teenagers use SMS to meet up and navigate places like shopping malls. When I was a kid and wanted to meet friends on a Saturday, we would arrange to meet outside Burger King at one o'clock. If you missed them, that was it, your day was ruined. Today, kids move around an urban space in a very dynamic way, following their 'herd instinct'. I am more interested in the mode/mood of specific (groups of) users rather than necessarily in their actual location, and how that mode/mood affects their appreciation of the location. *Flâneur* theory is a really useful way of interrogating set or dynamic patterns of behaviour and movement in urban spaces.

MCKEE That brings me back to galleries: Whether people ought to be surprised when entering a different kind of space or not. When people visit a gallery they open themselves up for surprises, for the unexpected. This might affect what one can or cannot do in that specific space, even though the gallery is a very predictable, clinical sort of space.

YUILL Where does the gallery happen? Things are changing now. Physical buildings such as galleries become less relevant or acquire a different relevance. In the same way, bookshops have introduced cafés as part of the challenge to the rise of online bookselling. People visit shops for the products but also, and often more so, for the social experience. Does that apply to the gallery too?

MCKEE It does. The gallery experience becomes more valuable, comparable to the novel becoming irrelevant with the evolution of cinema. Since the novel ceased to exist as mainstream art form, and took on a more secondary, marginal existence, it has become more interesting. Galleries too are becoming more marginal and therefore their awareness of what they can offer is growing compared to a situation when galleries were

centres of education, interpretation and authority.

CHALMERS Galleries have always operated on the assumption that they attract visitors or if not, they would be supported anyway. If the notion that galleries are good because they edify the population and, therefore, should receive government funding is fading, the situation will change inevitably.

LOCKE In our building we are currently creating a physical space for showing new media work similar to the media lounge concept. It has been a struggle because the building where I work accommodates offices for software and film companies, and a café, but it is not a place people would traditionally visit in order to see art. The exhibition space is located right next to the reception in order to target both exhibition audiences as well as other users/visitors to the building. The space we are converting is a corridor, which blocks out at the end, and we are programming it in terms of attention spans required for viewing the work: five-minute zone, ten- and thirty-minute zone. Thus the respective work on display interacts differently with the viewer. The five-minute zone will contain a lot of displays with textual information including products designed by tenants of our building. It will be a passive zone in that it requires looking and reading but not a real 'engagement'. The ten-minute zone will accommodate low-level interactive works. Like in our first show, we have got some of *Grey World's* interactive furniture that motivates its user to play with. The thirty-minute zone will house web terminals directed at people who are committed enough to spend a longer period of time. Its work might motivate people to return to it several times over a couple of month.

YUILL Traditionally, the gallery pre-empts people's behaviour. It predefines why they go there, how they behave. In contrast, Matt has talked about the exhibition space in terms of identifying emerging behaviour, i.e. the audience pre-empts the artistic event and one can come along after it and bracket it.

CHALMERS It is a to-and-fro. The space becomes increasingly conversational and thus more interesting. And it is a heterogeneous space in terms of the building's diverse users, who will adapt and change it gradually. Different smaller centres of gravity will emerge through the different groups of the public who will engage in various ways with the display. Technology is beginning to open up and enable the audience to interact with the work, rather than just being presented with a finished artefact, from the presentation of the finished artefact to its coming into being.

YUILL In a way, this also means moving from the artwork as process to the gallery as process . . .

CHALMERS It also means back to the studio in order to see how the work is emerging before it is presented in the gallery.

MCKEE Process forms part of the gallery as well as of curating. Objects are placed in a specific way, and thus trails are being set up in the gallery space. The curator suggests the way in which the visitors will walk around the exhibition. Yet, the audience through their actual behaviour may propose other trails.

LOCKE We use deliberately a very flexible way of designing the exhibition

space. All the furniture in the space will be moveable, so that it can be re-arranged with every show in order to reinforce or prevent certain patterns of behaviour. We already have web terminals in our café space but sometimes they get 'owned' by particular groups of people. Sometimes that is really cool and we would like to encourage it but at other times we want to disrupt it. We want to be able to disrupt if we feel it is necessary, similar to supermarkets moving their goods around in order to break people's shopping behaviour by forcing them to renegotiate the space.

MCKEE Is the gallery a physical space or is it in your head?

LOCKE The Transmission Gallery in Glasgow provides a very good example in its strong link to a particular social group out of which grew its success during the mid 1990s. It is like a *Slashdot gallery.* Transmission tenants always turn over after two years, and therefore patterns cannot become fossilised but need to change and remain flexible.

YUILL The concept of trail, which Francis brought up, touches—in some ways—on Bill Hillier's work.[14] He is concerned with movement patterns through cities, defining space in terms of those patterns rather than through physical dimensions. He loosely relates this to a language model. The movement patterns have a 'grammar' based on how integrated they are. Integration provides an index of connections. Hillier suggests that the movement patterns are an artefact in itself beyond the actual objects that exist in the space.

LOCKE His key term 'space syntax', the notion that space accrues a vocabulary that is not permanently real, is very evocative for me. Urban planning allows one to see these processes of accretion, fossilisation and demolition over a long period of time.

YUILL He talks about children playing *Tig* and *Blind Man's Bluff* in spaces, which are already determined by certain movement patterns. By playing a game, the children superimpose a different type of behavioural pattern on top of the existing one(s), and recognise the space in terms of their game.

LOCKE Urban planning uses a great phrase: 'desire paths'. If there is a square of grass and people decide to cut across it, then, over the years, a bare patch of grass will become a trail. Urban planners call it a 'desire path' because by physically manifesting patterns of behaviour, literally, patterns of desire, it cuts through the official language of architecture.

CHALMERS There is another aspect of dynamism one can only experience in computing: dynamic re-classification or non-classification. Computing allows to draw from individual people, to combine or group them and to achieve an outcome that is not based on a prerequisite categorisation of the 'participants' or sources. This is a recent development that sneaked out from the evolution of recommender and collaborative filter systems. The Amazon book recommender is the prime example. Dynamic re-categorisation or non-categorisation enables such systems to readily adapt, blend, move and respond

LOCKE I definitely agree with that. You are talking about extremely fast feedback loops that are only variable because they are essentially ephemeral. In terms of post-structural theory, Hakim Bey's notion of the T.A.Z., the Temporary Autonomous Zone[15] describes this phenomenon. He defines it in a tongue-in-cheek way as a form of political structure, which contains the notion of ephemerality. In his search for a form of

14. Bill Hillier, *Space is the Machine: A Configurational Theory of Architecture,* Cambridge, New York and Melbourne, Cambridge University Press, 1996.

15. Hakim Bey, T.A.Z.: The Temporary Autonomous Zone, Ontological Anarchy, Poetic Terrorism, New York, Autonomedia, 1991.

radical non-governmental politics he concludes that all radical politics are essentially doomed to become what they replace. Focusing on the example of pirate utopias, he looks at those islands where pirates used to trade. These places existed on a need basis. When they were temporarily inhabited markets were held and trade undertaken. With the departure of the pirates, market and trade disappeared too, moved on to another place, shifted. Those islands epitomise the relevance of behavioural patterns for social existence. The concept of T.A.Z. is growing in relevance at present. I have appropriated the term to describe the way in which communication infrastructures have erupted physical space. Until the emergence of the mobile phone, our interaction with communication networks was always architecturally defined.

CHALMERS Did the eruption not already happen with the invention of printing, or even when talking started?

LOCKE I am talking about electronic communications. Think of the telephone, it has always been related to architectural space. Skyscrapers became possible because of telephone networks, and the telephone itself has always had an eroded architectural presence, from the classic Gilbert-Scott red telephone booth to scant plastic goods. Increasingly it has leaked into public space. When one wanted to interact with the network one had to step into a physically different space which meant that one left a social space in order to enter into a one-to-one communication space. The mobile phone completely breaks up that architecture and impacts on social spaces in that society does no longer share a common vocabulary, that enables its members to communicate the shift between a public and a private communication space.

CHALMERS I do not necessarily agree with this picture because the situation is more complex. Mobile phones are just another medium. Instead of defining communication space architecturally—static and fixed—one might look at it gesturally. People turn away when another person is engaged in a one-to-one communication via the mobile phone, or taking out the phone signals to others that one's attention is being diverted temporarily. The other people may then concentrate on each other.

LOCKE That is not a common vocabulary, a protocol we share as a society.

CHALMERS We are coming to share it. It is in the process of being built up, but it takes time to share it. This vocabulary or protocol compares to the conventional mode of contemplation required when visiting a museum or gallery.

LOCKE However, the instances I mentioned before are of interest because of their ephemeral, unfixed nature. I have 'hacked' the T.A.Z. to come up with a T.I.Z., the Temporary Intimacy Zone. T.I.Z. signifies the eruption of intimate spaces in public spaces. Both kinds of space would have been architecturally defined previously, but have now an ephemeral, contingent, on-need basis. In this context I am interested in how we read and use the city now.

YUILL Tell us about *Surrender Control*.

LOCKE *Surrender Control* developed out of Tim Etchell's interest in SMS as a space and its intimacy. He wanted to find out how unpredictable behaviour could be provoked. A performance is set up in a space that cannot be controlled or pretended to be controllable. Technology is

explored as a means of play and escape from reality. The notion behind *Surrender Control* was that all of us secretly like the idea that somehow something big and cataclysmic is going to happen, and you can drop everything and escape reality for a while. It is a common urban theme that a disaster causes the temporary closure of your office and so you go off and play in the fields. The project operates as follows: people sign up for a particular series of SMSs and at unspecified times they will then receive messages in which they are asked to do certain things. It starts with low risk requests such as looking to the stars, trying to establish eye contact with someone else, etc. Gradually, the personal risk involved in carrying out the requests will increase. For example, participants will be asked to touch someone or to touch two people at the same time, to follow the next person to the toilet, etc. My favourite request is: 'Write the word sorrow on the back of your hand and leave it until it fades.' The next level involves potentially even more risky activities, such as: 'Ring a number which is one digit different from that of a friend, and if someone answers, try to keep them talking.' Then, the SMS orders become more and more bizarre. The project finishes with the final message: 'Forget everything you have just done, do not talk about it to anyone else.' We carried out a test and sent an email out to twenty-five people asking them if they were prepared to participate in such a project. Simultaneously, we set up a website where they could give us anonymous feedback about how, where and when they responded to the SMS requests. A couple of participants regarded the project as a form of catharsis in that they used it as an escape. Escaping reality is what seems to attract people to such a project. One participating woman, who had split up from her boyfriend four days before the start of *Surrender Control*, started to use the structure of the given 'orders' to legitimise her behaviour which she really wanted to act on. She wanted to be irrational, she wanted to freak people out. She was going through this immensely emotional period and was using the project as a crutch, in a way, to work through her situation. She used to anticipate and look forward to these messages as a kind of release valve.

YUILL What if someone hacks into *Surrender Control*?

LOCKE There are two ways in which people could ostensibly hack it. In a sense the performance predicates a form of hacking because you have the instruction, how do you interpret it. Hacking is about interpretation. No matter whether it is called hacking or performance, such interventionist activity requires you to know if the project is based on a rule structure that needs to be obeyed or not. The project can be hacked in different ways. To simply ignore the SMSs, would kill it off, and we could not prevent that. The project could be hacked by replicating the experience. This brings us back to games culture, where a hack of the engine is as legitimate as the original engine. Such a move would raise all sorts of issues in terms of responsibilities for the actions. We provide participants with narrative scenes via SMS. They own the story from that point on . . . We cannot be held responsible for how the participants interpret that environment at all.

CHALMERS If somebody sends out messages ordering existentially
threatening actions such as 'give all your money away' or 'kill yourself'
and receiver carries them out, that would bring to the fore that the project
does not exist in isolation from the rest of the world but that it is still
controlled by a much larger set up.

Remoteness—
A Study in Electro-Mist

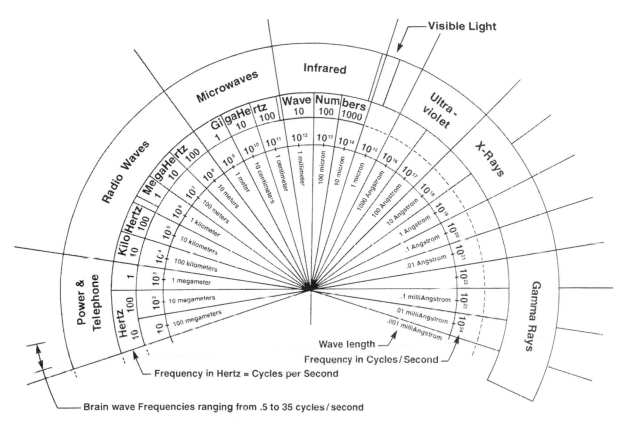

Chart of the range of electromagnetic spectrum

Judy Spark

JUDY SPARK
Artist
Born 1965 in Glasgow, Scotland, UK
Lives and works in Glasgow

That the air around us is now saturated with man-made electromagnetic fields is understood. We are suffering from Electro-pollution. There are many claims that this phenomenon is causing people to become ill, support groups for the 'Electro-sensitive' have sprung up. These claims are frequently dismissed as more and more electronic items are recklessly produced with built-in obsolescence to satisfy insatiable greed. If there are effects upon us they are not yet properly understood. The idea cannot be overlooked that Electro-sensitivity may be part of a more general modern malaise. Many of us leave the city at weekends and holidays perhaps seeking solace or some sort of connection to the land, to nature, which we find increasingly difficult to maintain from day to day. But we have started to take our electronic equipment with us.

Concerned that this type of pollution may be spreading to wilderness areas, your correspondent elected to make some frequency readings in the semi-remote, lush and very beautiful area of Moidart in the Scottish Western Highlands. I determined to research beforehand which frequencies of the electromagnetic spectrum I would be most likely to detect. Please see above spectrum chart.

EMFs from powerlines, operating at very low frequencies around 10–15 KHz, were unlikely to be detected by anything but the most sensitive equipment as I could find no lines of transmission in the area that were detailed on Ordnance Survey maps. The routes of underground cabling are however undocumented. RF radiation from mobile phone transmitters, operating between 900–1800 MHz, travels in a straight 'line of sight' with a slight downward turn. In areas where there is a health concern the level of this radiation can be easily monitored. Coverage maps of the main mobile phone operators in the UK showed a blank here and I could get no signal on my own phone. I was likely therefore to have succeeded in finding an area free, for the moment at least, of this variety of EMF.

It seemed that the frequency ranges most likely to be present at this spot would be between the ranges of around 0 KHz–60 GHz the area of the spectrum on which a wide variety of radio transmissions operate. I became interested particularly in the shortwave radio bands.

Shortwave radio signals can be of both international and domestic origin. They differ from conventional radio broadcasts as they do not pass through local masts but travel from the original transmitter, be that on the other side of the world, bounced between the earth and its natural ionosphere to the receiver. The capacity of the ionosphere to reflect radio waves is dependent on its being charged by the sun's radiation. It is said that higher frequencies travel better during the day and lower ones at night. I decided to monitor a sample of shortwave signals, those falling between 7.93 and 15.10 MHz, by way of a portable shortwave radio.

A circle of 14ft in diameter was marked out on the ground. The point at which each signal could be heard most strongly was marked with a cane, the

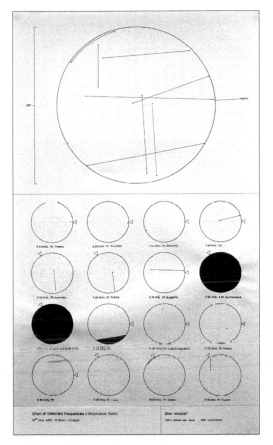

Chart of detected frequencies

height of which depended upon the position of the radio's fully extended aerial. Wet ground conditions may have affected the optimum height for these broadcasts as water both reflects and absorbs electromagnetic signals. Where a signal could be heard clearly between two points, a string was tied between the canes. The direction of travel of each signal was marked by an arrow. In this way I effectively surrounded myself visibly with what I was hearing. The accompanying chart may be used to interpret the photographic image of this experience.

VHF signals, those between 88–108 MHz more commonly known as FM, could be heard distinctly across the circle from ground level upwards as could broadcasts on the MW (medium wavebands) operating at 53–160 MHz These waves also travel in straight lines of sight which is why conventional radio transmitters are usually sited fairly high on hills away from buildings.

To date the author has discovered one man-made emf free zone. For obvious reasons the exact location of this site must be kept secret. It can be revealed however that this remarkable area lies somewhere on the North-east coast of Scotland. Investigations continue.

The question is: will the idea of remoteness or wilderness, over time, become simply a concept, a memory?

I wonder where we will go when there is nowhere left to 'get away from it all'?

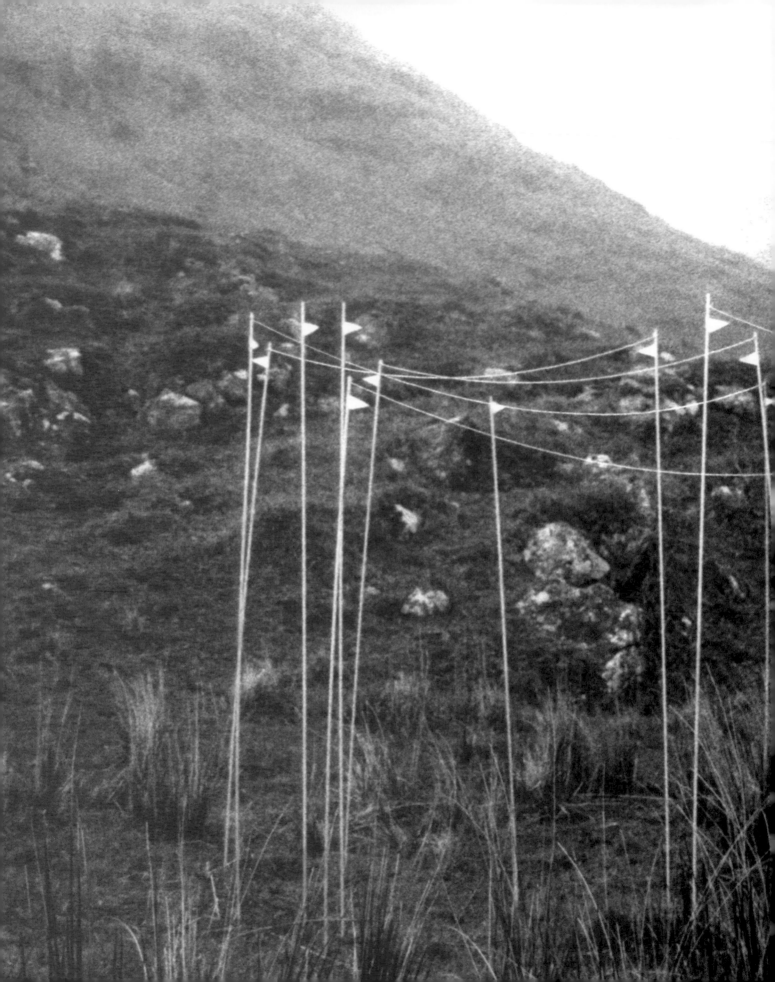

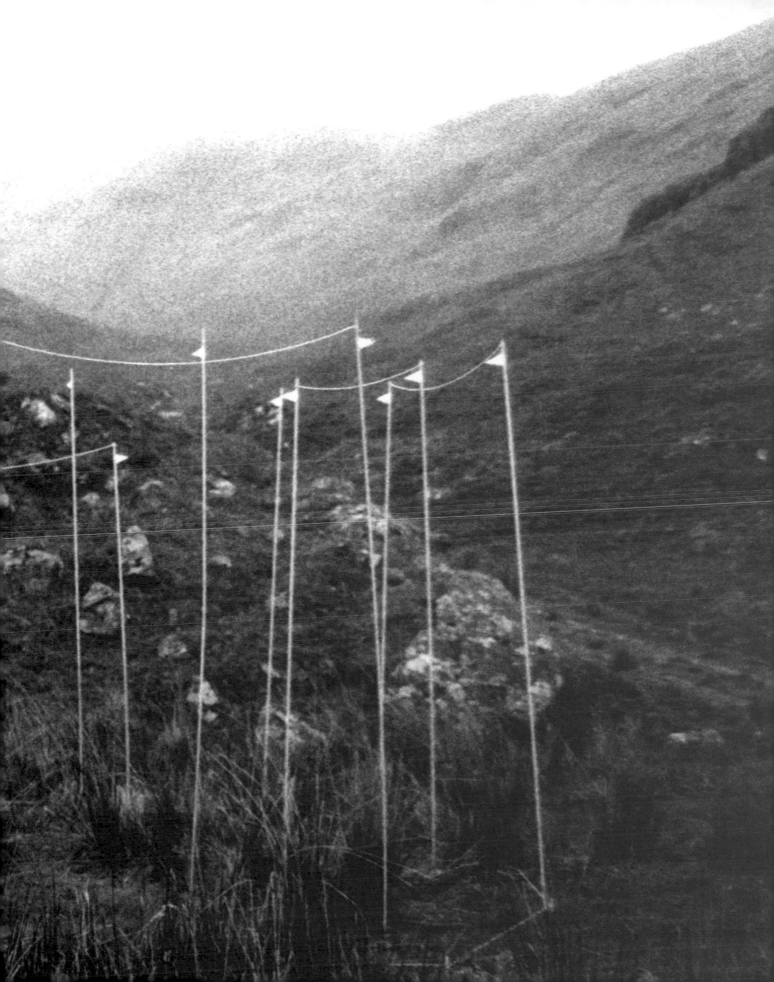

The Loch Sheil / Fort William area
The map shows the positions of
the UHF transmitters.

Glen Moidart
The map shows the location and
topography of the monitored site,
and reveals the path the received
signals are most likely to have
taken from a local transmitter.

Hacking the Art
Operation System

Cornelia Sollfrank
in conversation with
Florian Cramer

CORNELIA SOLLFRANK

Artist and Founding Member of Old Boys Network (OBN)

Born 1960, in Feilshammer, Germany

Lives and works in Hamburg, Berlin and Celle, Germany

FLORIAN CRAMER

Lecturer in Comparative Literature
Freie Universität Berlin, Germany

Born 1969, Germany

Lives and works in Berlin

The discussion between Cornelia Sollfrank and Florian Cramer took place on 28th December 2001, during the annual congress of the *Chaos Computer Club* (German Hackers' Club) in Berlin.

FLORIAN CRAMER I have a number of questions on various thematic complexes which in your work continually seem to be referring to each other: hacking and art, computer generated, or more specifically, generative art, cyberfeminism, or those issues that your new work entitled 'Improvised Tele-vision' throws up. And of course the thematic complex of plagiarism and appropriation . . .

CORNELIA SOLLFRANK It is the relationship between these complexes that is so interesting and difficult and that I often find myself arguing about. To keep an eye on how these various activities link together is not easy, all the more since I am sometimes more involved in one field and at other times more in another.

CRAMER We are here at the annual convention of the *Chaos Computer Club*. For you, is hacking art and does hacking have something to do with art?

SOLLFRANK Both. Over the last four or five years in which I have been involved in hacking, I have increasingly come to the conclusion that hacking culture is always something that borders on a national flavour. That is why it is interesting to me to visit other countries and especially Italy, where it appears as if there does not exist the slightest fear of contact between artists, activists, philosophers, etc. There, they coexist naturally, dialogue with each other and create a common language in which they can communicate, which is something I have not experienced in Germany. As a female artist in the *Chaos Computer Club*, I have unfortunately come face to face with some of the worst preconceptions, accusations and verbal abuse in my life.

CRAMER You said: as a 'female artist' in the *Chaos Computer Club*. Where do you put on the emphasis, on being an 'artist' or being 'female'?

SOLLFRANK On both. As far as gender goes there is a basic frankness involved. If one deals with the same themes in identical ways and speaks the same language, gender is one hurdle less to cross. Yet, since that is seldom the case, gender becomes an obstacle. However, the bigger problem is art. This experience left me utterly dumbfounded. I was having a nice chat with someone at one of these parties and was asked what I do. When I replied: 'I am an artist', the reaction I got was a hoarse exclamation: 'I hate artists.'

CRAMER You did an interview with a female hacker at a *Chaos Computer Congress* in 1999.

SOLLFRANK Clara S0pht . . .

CRAMER Right. And you are working on a comprehensive video documentation of female hackers!

SOLLFRANK I am making a five-part series. Due to my experience in the

CCC, I narrowed my research down and tried to find women who see themselves as hackers. However they just did not exist. That is when I switched from the journalist-research modus to the artistic-modus and said to myself: I have to try and reshape this boring reality. And that is why I did the interview with Clara S0pht for example, who does not really exist. I just started to invent female hackers.

I gave a talk at the CCC congress on women hackers and showed the interview with Clara S0pht. It was pretty well attended, including a lot of men, who watched everything and then attacked me for not defending sufficiently Clara S0pht's privacy, because she had stressed that she did not want details about herself being publicised. At the end of the event I mentioned casually that the woman did not exist and that I had invented her. Some people were astounded. Quite unexpectedly they had experienced art, an art that had come to them, to their congress, and talked in their language. I found that very amusing. These little doses of 'pedagogy' can trigger off a lot and no doubt help the CCC to further develop.

CRAMER In the early nineties the art critic Thomas Wulffen coined the metaphor 'art operating system'. Can you relate to that concept in any way? Or do you find it problematic? Your artistic hacks that you have mentioned do not engage directly with the 'art operating system'!

SOLLFRANK I can relate to the idea in a big way because what interests me most in art is its operating system, the parameters which define it, and how they can be changed and change based on the possibilities created by the new media technologies. The concept of the artist, the notion of an artistic programme, an artist's body of work, and last but not least the interfaces—who and what will be exhibited and who will look at it—also belong to the operating system. This system is actually what interests me most in art. In order to intervene and be able to play with the system I have to know how it functions.

CRAMER But then, is it not it difficult to be a net artist as well? In the example of net.art, one could see how at the very moment at which no new objects—which lent themselves for display—were produced, net.art lost its footing and was not given proper recognition in the art world. I still find it astonishing how much net.art has to battle in order to be taken seriously in the first place by the art operating system. For you as an artist, is it not difficult to seek to hack the art operating system, and to do so as a net artist?

SOLLFRANK First of all I do not see myself solely as a net artist, but rather as a kind of concept artist. I find the net very interesting indeed, and to be active within it fulfils many of my wishes; but that aside. I also work with video, text, performance and whatever else is required for a particular project. That net.art is not recognised in the art world and experiences problems there, is primarily due to the fact that, in my opinion, there are no pieces/objects which can be exchanged from one owner to another in a meaningful way. An art that is incompatible with the art market is hardly of any interest, because, after all, the market functions as governing force in the 'art operating system'. Another further difficulty lies in net.art's lack of qualities in terms of physical display. What justification is there to show net.art products in the 'White Cube'? In that way all curators have

to ask themselves: why should we actually exhibit net.art in our gallery or museum? Some net artists quickly understood that they would not get far in the market with their non-commodifiable art that is difficult to (re)present, and expanded their working practices towards installations. That has worked well—just as it did with video art. The expansions and changes net.art is currently undergoing are not new phenomena at all. We have also seen it happening with ephemeral art, Fluxus and Performance for example, or with art forms, that could be technically perfectly reproduced, such as video and photography. All those art forms had enormous problems at the beginning, but then opportunities surfaced in the market and certain intermediaries really supported them and managed to create a space for them. And when it all becomes too much, another decade of 'new painting' is heralded in order to let the market recuperate.

Nevertheless I think there is an interest in the art world regarding net.art. For a long period it was received with a lot of hype, and at the moment I see a kind of consolidation. Ultimately, there are a few big institutions like the Guggenheim, Tate Modern or the Walker Art Centre that commission new works. What goes wrong in net.art is that artists— I am talking mainly about the group net.art and its scene—have not developed collective strategies as to how they should deal with the art system—which was one of the great strengths of the Fluxus artists. The willingness to accept that such a problem even exists is missing in the first place.

In 1997, a further symptom of this kind became visible in the form of the first competition for net.art a museum has launched: *Extension* by the Hamburger Kunsthalle. Like the introduction of net.art at the *documenta x,* artists for the Hamburg project were very uncertain and did not know how they should deal with the idiotic and incomprehensible conditions. And so they contributed half-heartedly. This was the time when it would have been easy to hack the 'art operating system'. It was definitely a missed opportunity.

CRAMER For your project *Female Extension* you submitted several hundred art websites under different female artist names to the net.art competition *Extension*, websites which were in fact generated by a computer programme. Is the generative simply a vehicle, a means to an end for your work? *Female Extension* was also a 'social hack', a cyberfeminist hack of the net.art competition. It was actually pretty irrelevant how your generators were programmed, was it not?

SOLLFRANK In principle, yes, it was. At the start I intended to design all the websites manually, using copy and paste, because I was not capable of programming them. The programming happened more by chance through an artist friend of mine. I was very happy with the results; the automatic generated pages looked very artistic. The jury was definitely taken in by it, although none of my female artists won a prize. Through *Female Extension* and the social hack I got caught up in the idea to conceptualise the generators in even more detail. Three versions have been around for some time now: one works with images, one combines images and texts in layers on top of each other, and one is a variation of the *Dada Engine.* The latter one is specialised in texts and invents

wonderful word combinations, sometimes even with elements from different languages. Two more are currently under development for particular applications.

CRAMER Is it necessary, then, to use labels like 'net.art' at all when the medium is not that relevant?

SOLLFRANK I think it makes sense to use such labels in the beginning, when a new medium is being introduced, and actual changes come along with it; during the period when the actual medium is explored like JODI did, for example, with the web/net, or Nam June Paik with video.

CRAMER Looking at your art, is it not the case that projects like the net.art generator develop their concept, their systems of 'social hacks' from the media?

SOLLFRANK That is true in this particular case. But it is not necessarily the way I work. The term 'net.art' functioned also as a perfect marketing tool. And it worked until the moment it gained the success it had headed for. Then everything collapsed.

CRAMER In your new work *Improvised Tele-vision,* you refer to Arnold Schönberg's piece *Verklärte Nacht* recorded

 a) by Nam June Paik, who let the record run at a quarter of its normal speed, and

 b) by Dieter Roth, who restored Schönberg's music to its original tempo by speeding up Paik's version.

 That immediately reminded me of the literary theory by Harold Bloom, his so-called influence theory, according to which the history of literature is the product of famous writers, who each in turn adopt his/her predecessor as an oedipal super-ego . . . and who then again manages to free him/herself from the predecessor.

SOLLFRANK Oh really? The subtitle for *Improvised Tele-vision* was originally *apparent oedipal fixation,* which I then discarded. And it was the 'apparent' that was important to me.

CRAMER That is what I assumed. There are—from my point of view—these tremendous artists, like Schönberg, Paik and Roth, who take each other down from the pedestal in order to put themselves on that very pedestal.

SOLLFRANK Exactly.

CRAMER But is not that the tragedy of every anti-oedipal intervention automatically—whether it likes it or not—becomes inscribed in the oedipal logic again? That is what I see in this example.

SOLLFRANK If that is the case, then that is definitely tragic. Probably that is the reason why I have turned it into such an issue. I find the public's reaction—which was partly very aggressive—quite amusing. I was subjected to accusations such as: 'You do not want to be any different than they are.' However, the work is actually about showing the processes involved in the 'art operation system', how it functions. It is logical, that I cannot extract myself from the system, if I want to be part of it.

 Another example for this, which once again leads us back to the market compatibility of net.art, is the invitation by a five-star hotel to partly decorate their interiors. Actually, I was always fairly sure that I was the last possible artist anyone would invite for such a task. But it did interest me and I began to experiment with ideas and approaches. Fortunately, I have the net.art generators, which can endlessly produce work for me. It meant

knowledge and technology—a social issue. The second area—if access for women exists and the necessary skills are there—deals with the conditions of the net and the workings of this medium. What are the factors that determine its difference in terms of *what* is made? There is not much convincing stuff in existence regarding the latter. A lot of it is arid, ill-defined, essentialist crap, with which I want to have little to do, because it reaffirms the already existing and unfavourable conditions rather than triggering something new.

There are not that few female artists whose approach is based on the idea that women have to develop their own aesthetics in order to counteract the dominant order. But I have always had problems with such an approach and did not know I could make productive use of it without predicating myself again in strict roles and definitions. That is the problem with Essentialism. The claimed difference can easily be turned against women—even when they defined it themselves. In other words, such an approach does not take you anywhere and provides just another trap. Besides, one of the miseries of identity politics has been that the identities certain communities and groups had developed were seamlessly incorporated by, for example, advertising—a complete reversal of their actual intentions.

CRAMER I have noticed that women are amply represented in the code-experimental area of net.art. JODI, for example, is a masculine-feminine couple, the same goes for 0100101110111001.org. Furthermore, *mez*/Mary Anne Breeze springs to mind or *antiorp*/Netochka Nezvanova, the latter, we now know, has a woman from New Zealand forming the core figure.

SOLLFRANK I am currently working on an interview with Netochka Nezvanova in which she tells me everything! What she thinks about the world and especially about the art world.

CRAMER Who or what else fascinates you?

SOLLFRANK I find Netochka Nezvanova extremely interesting as a phenomenon, and ask 'her' things like, how much does her success have to do with the fact she is a woman. Ultimately, though, there are several people involved in forming the character. I have asked so many people about her, and everyone had contradictory information about her. The last theory that I heard led me to the media theoretician Lev Manovich as the core of N.N. It is great what Netochka Nezvanova triggers in the minds of other people. Therefore, it is a good concept. But I am working on finalising that concept. I want to kill 'her' by doing an interview in which she reveals all of her strategies—something she would never do anyway.

CRAMER Would it be possible for you to work in any context? We met here at the annual conference of the *Chaos Computer Club*. But would it also be possible to meet at the annual congress of stamp collectors, and would that then constitute the social system you would intervene in?

SOLLFRANK Theoretically, yes. I think anybody who manages to get along with hackers and hacker culture would not shrink back from anything—not even stamp collectors or allotment holders.

CRAMER ... or hotel corridors.

SOLLFRANK No, theoretically a lot is possible, but not practically. My interest is not just formal and not only directed towards the operating

system. It is an important aspect, but when the arguments and the people within the system are of no interest to me, I can hardly imagine working there.

CRAMER That implies that at the hackers' convention here, your reference would be the fact that people play with systems, and to critically think about those systems?

SOLLFRANK Yes. I am also interested in the fact that hackers are independent experts, programmers, who work for the sake of programming, and that they do not serve economy or politics. That is the crucial point for me. And that is also the reason why hackers provide an important source of information for me.

CRAMER That takes us straight back to the eighteenth-century classical concept of the autonomous artist, the freelance genius. S/he is no longer employed, and gets no commissions, but is independent and does not have to follow a given set of rules.

SOLLFRANK Maybe you are right, and my image of a hacker has in fact a lot to do with such an image of the artist. But reflecting upon the role of art in society in general, I would prefer to consider art as autonomous, rather than to think of the individual artist as autonomous—given that the idea of autonomy per se is problematic. I prefer art as observing, as positioning of the individual, as commenting, as an attempt to open up different perspectives on what is going on in society. And that is exactly what is under threat. The contradictory thing about autonomy is that someone has to protect/finance it. And it is most comfortable when governments do so, like it was common here in Germany over the last decades. I think that way the greatest freedom is ensured. Examples which illustrate my theory are Pop Art and New Music; in the 60s and 70s, artists from all over the world came to Germany because there was public funding, and facilities to work, which existed nowhere else. I consider it as one of the tasks of a government to provide money for culture. The development we are facing at the moment is disastrous.

A short time ago somebody asked me how I would imagine the art of the future, and after I had given it some thought, I came up with the image of an open-plan office, packed with artists who work there, all looking the same and getting paid by whatever corporation; an image of art which is subjected, and succumbs, to the logic of the capitalist economy. This does not mean that I would reject all corporate sponsoring, but it should not become too influential.

CRAMER Are the new media artists not playing the role of the Avant-garde, because so much and so many depend on new technologies?

SOLLFRANK Absolutely, and I think that is really a major problem. Avant-garde . . .

CRAMER . . . but in an entirely negative sense.

SOLLFRANK Basically, yes. It is a difficult field to play in. Some artists are thinking of alternative works, like low-tech projects. As another example I would highly appreciate if *ars electronica,* which obviously suffers from a lack of ideas and inspiration, would choose the topic of *Free Software.* They could do without their corporate sponsors, and only award art works that are produced using *Free Software* only. It would be really exciting to see what you can do with it.

(At this point we switched off the tape recorder and kept on talking about the necessity of doing things on the one hand side, and discarding them again on the other hand. During that the conversation turned to Neoism and its internal quarrels.)

SOLLFRANK Such quarrels can become very existential, very exhausting, and weakening. Things tend to become incredibly authentic—something I try to avoid otherwise.

CRAMER But it is important. When I hear standard accusations, saying that dealing with systems, disrupting systems through plagiarism, fake, and manipulation of signs, is boring postmodern stuff, lacking existential hardness, my only answer is that people who say this, never tried to practise it consequently. Especially, on a personal level, it can be deadly. You have mentioned the group –*Innen* before, a group you have obviously been part of in the early 90s, before the days of net.art . . .

SOLLFRANK Yes, between 1993–96.

CRAMER And, if I get that right, the group was also based on a 'multiple identity' concept.

SOLLFRANK Yes, and although we handled it very playful and ironic, it started to become threatening—so much that we had to give it up. We had practised the 'becoming one person' to an extreme by looking exactly the same and through a standardised language. Eventually we felt we needed to escape from each other, and did not want to meet any more.

CRAMER Is this the point where art potentially becomes religious or a sect?

SOLLFRANK Perhaps, if you do not quit.

CRAMER Designing such systems also has something to do with control and losing control, right? In the beginning you are the designer, you define the rules, but then you get involved and become part of the game yourself, and the time has come to quit.

SOLLFRANK Well, certainly I do have my ideas and concepts, but the others might have different ones. The whole thing comes to an end when the debates and arguments are not productive any longer. With the 'Old Boys Network' we are currently experimenting with the idea to release our label. To think through what that actually means was a painful process. You think: 'Oh God, maybe somebody might abuse it, might do something really horrible and stupid with it. That is awful.' But if we want to be consequent, we have to live with that. One big trap for us was, that we called it 'network', although it actually functioned as a group.

CRAMER But this seems to be a very popular self-deception within the so-called net cultures. I would also say that *Nettime,* too, and the net culture it supposedly represented, was in fact a group, at least until about 1998.

SOLLFRANK That is the only way it works. There is no alternative way a network can come into being. At some point there have to be condensations, and commitments. 'Networks' do not require a lot of commitment.

CRAMER How do network and system relate in your understanding?

SOLLFRANK I think a system is structured and defined more clearly, and has obvious rules and players. A network tends to be more open, is looser.

CRAMER One could claim that purely technical networks as well as purely technical systems do exist. Your work intervenes alternately in social and

technical networks. But, in the end, your intervention always turns out to be a social one. Can you think of networks and systems—referring to the definition you have just given—without social participation?

SOLLFRANK No, not at all. Because the rules or the regulating structure always is determined by somebody. Likewise, computer programmes are often mistaken as something neutral. *Microsoft Word* for example. Everyone assumes *MS Word* can only be the way *MS Word* is. But that is not the case. It could be completely different.

CRAMER There are also earlier experiments within art, on designing self-regulating systems. In the 1960s, Hans Haacke has built his *Condensation Cube*, made of glass. Water condenses on its side walls corresponding to the amount of people who are in the same room. Would such a thing not be of interest to you?

SOLLFRANK No, I do not think so. It is also typical for a lot of generative art that one system simply is being transformed into another one. I find this totally boring. For me, it is important that the intervention sets an impulse, which results in—or at least aims for a change.

Anti-Corporate Inc.

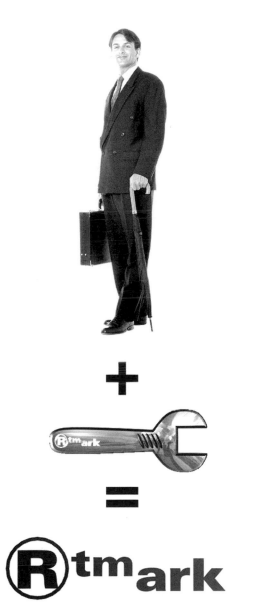

RTMark
in conversation with
Simon Yuill

RTMark
Established around 1994

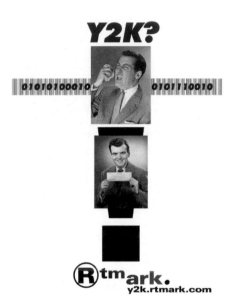

RTMark present themselves as the 'anti-corporate corporation'. This interview with RTMark representative FRANK GUERRERO was conducted by email a few days following the attacks on the World Trade Center in New York and the Pentagon in Washington on September 11th 2001.

SIMON YUILL You have adopted the legal status of the corporation in order to facilitate anti-corporate strategies, could you explain, firstly, how this works and, secondly, how you came to the realisation that this was an appropriate model for activist activity?

FRANK GUERRERO Corporations were created to raise money and displace liability. The concept of a group of people getting together and forming an independent body (corpus) so that they could pool their resources and undertake dangerous and capital intensive business dates back to the seventeenth century. One of the benefits of incorporation is that it allows corporate owners (now shareholders) to operate with relative impunity . . . so that if, for example, a bridge they are building falls down in a massive flood, they cannot be held criminally liable. RTMark recognised that although this idea makes possible modern economies, it also allows people to engage in all kinds of criminal and anti-social activities that they would not risk if they were actually held liable for their actions. And people who invest in corporations today—the stockholders—are essentially beyond reproach for the actions of the corporation. In fact, it creates a diabolical situation, where the corporation, by nature of its charter, has but one goal, and that is to make money for its stockholders. So if it is actually more economically efficient to engage in activities that go against the public good—such as polluting, or operating at risk to public health—the corporation not only will do it, they are required to do it to make maximum profits.

RTMark therefore casts itself as a corporation with the idea that people, who attack corporations, should have at least the same liability limitations that people have, who invest in corporations. Therefore, RTMark becomes a corporation; and investors can buy into anti-corporate activist projects without fear of recrimination.

In reality, all of these ideas have yet to be tested in court, and because the rules of incorporation are so narrowly focused on making money rather than creating any kind of good for the world, we would almost certainly lose our case on technicalities. But by becoming an anti-corporate corporation whose business is sabotage of corporations, we feel that RTMark demonstrates in a tangible way exactly how stupid, contradictory, and anti-human corporations are.

In the United States, corporations have the legal rights of people. These legal rights were cemented in an 1886 Supreme Court case. The Pacific Railroad Company used a new law that gave the rights of people to freed slaves (the fourteenth constitutional amendment) to argue that since a

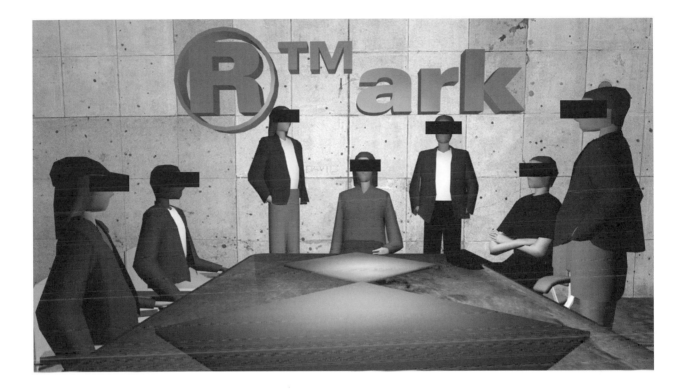

corporation was essentially a person—just as a freed slave was a person—
they should have the same legal rights as a natural person.[1]

One of the primary reasons RTMark went public with a web presence
in 1997 was to publicise this information. In the United States, very few
people had considered this a problem because it was simply taken for
granted, just as very few people had considered the history of the word
'corporation'. Giving corporations the legal rights of people corrupts,
perverts, and destroys the charter of democratic government, since it
cripples the public ability to regulate corporations and allows the
corporations to influence further laws and government decisions at a
scale proportionate to their wealth, which is far greater than living people.

RTMark uses the fun-house mirror to reveal the weaknesses in this
logic. Why should corporations have the rights of people? That can only
serve to corrupt and undermine democratic rule.

YUILL What have been some your most effective ventures?

GUERRERO We have supported dozens of successful projects since 1993.
Synopses and press about our most high-profile successes can be found
on our web site. We are very happy about the success of recent projects—
such as the impersonations done by a group called *The Yes Men*,[2] who
infiltrate business conferences posing as representatives of the World

1. A more detailed history of corporate
personhood in the United States is
available at:
http://www.iiipublishing.com/afd/
Coperson.htm

2. For further information see:
http://www.theyesmen.org

**We're building
a better wrench.**

**Bringing IT to YOU!
www.rtmark.com**

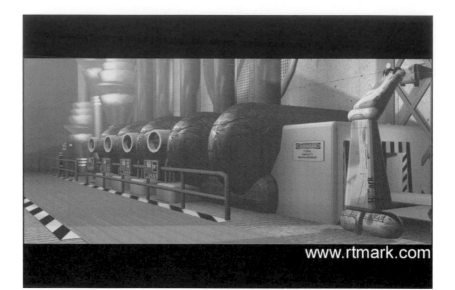

Trade Organisation. Older projects that are still favourites include things like the *SimCopter Hack,* where a programmer was awarded a cash investment for adding homoerotic content to a popular video game, which was not discovered until after the product was on the shelves. Let us just say that players were surprised to find that in addition to flying the helicopter, they could also land and disembark to have sex with men in swimming trunks on the ground.

YUILL The other side to this is that you are a non-art group; your main goal is not the creation of artworks or the development of artistic careers but rather the production of political actions, yet you often work within the context of existing artistic structures and through artistic organisations and institutions—such as appearing at conferences and art festivals. You have said that artists are often the most readily sympathetic to what you do, or understand it more readily. What do you feel are the benefits of working in this context?

GUERRERO We have been able to use art networks to our advantage logistically, sometimes leveraging the budgets of institutions to do our work, and sometimes simply using the travel associated to develop connections necessary for pulling off bigger projects. For example, last spring RTMark participated in an art event in Bologna. There we met people from Finland. When *The Yes Men* needed logistical support in Finland, we were able to hook them up with our new Finnish friends, and as a result it made a logistically complicated action much simpler.

The activities that we undertake are often embraced by artists because they fit within a history of similar critical actions in cultural production

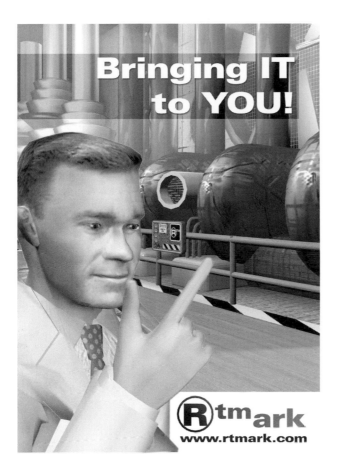

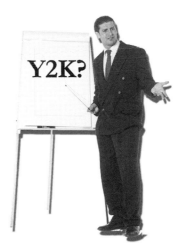

... things done by satirical writers like Jonathan Swift or even Diderot, or avant-garde artists like the Hydropathes in fin-de-siècle France ...

But it is also fair to note that we have spoken at other types of events—advertising conferences, law conferences ... and those venues, where people understand you from their perspective and from a different context, often become the most generative and interesting for us.

YUILL One of the weaknesses of trying to work politically within the art-world is that anything you do can so easily be neutralised by virtue of its 'artistic' associations. Political action routed in artistic gesture becomes merely a stylistic rather than ideological or pragmatic stance. 'Activism' is quite a fashionable branding right now in the cultural sector. How do you feel RTMark manage to negotiate with or insure against such potential compromises, or do you feel they can work in your favour?

GUERRERO It is sometimes a problem to be seen as 'artists' especially since in the United States, for many years, there has been an active conservative campaign to discredit the value of any cultural activity whose purpose is not to make money. The result is that by the standards of the general public in the United States, if something is understood to be art it automatically becomes unimportant and frivolous. Conversely, in activist circles, since art is often understood in the context of modernist practice and money, being associated with art and financial structures that

support it can undermine the meaning of what you are doing from their perspective. It is a bit of a catch 22. To stay effective in the mass media, we are careful to avoid the word art . . . because it immediately can turn off some of the audiences we most want to reach.

YUILL You recently backed an action at the G8 conference in Genoa in which people held up mirrors to the conference organisers. This summarises RTMark in a way: you are creating a mirror for the corporation, holding up the corporate 'other'. This is one way in which an artistic strategy can work politically and socially, as a model, or hypothesis of other ways of operating. *CueJack*, the barcode scanner for home use, which re-engineers consumer technology to empower consumers in a way the manufactures might not intend, is a similar example. How effective do you feel such strategies are and where does their influence go?

GUERRERO Very often the effects are subtle and hard to measure, since they are aimed at changing public sentiments through pedagogy, rather than directly changing a law or bringing down a system completely. We see these activities as essentially a component of a very broad based set of actions taken on by many groups and individuals. In many ways, our approach is limited in this regard—however we hope that it will help to prepare the public for adopting real legislation that protects people and the environment against corporate predations.

The *Archimedes Project* in Genoa does stand for many of the reflective practices that we engage in at RTMark . . . although in that particular case it appears that when people were being attacked by the police, some of them switched from merely reflecting the situation into acting upon it, as they tried to block the baton blows by hurling the mirrors at their attackers . . .

YUILL An alternate way of looking at this issue of the 'mirror' is the way in which brand-based corporate practice is almost like a mirror to conceptual art practice, it is not the products, it is the ideas that people buy into. In this sense Nike are better known artists than Kosuth or Koons. Whereas back in the early 1970s, projects like the *Artists Placement Group* sought to put artists into governmental and commercial institutions in order to explore possibilities for opening them up to the public. Now, artists are employed by corporations as 'creative consultants'. I have heard that Charles Schwab even have a consultant on Rave Culture. This comes back to the issue of artistic practice possibly not being a viable place for developing oppositional tactics, but it also raises the question: are Starbucks, Benetton, etc., are more effective cultural commentators than any gallery or art scene?

GUERRERO The 'commodification of dissent', as Tom Frank so eloquently put it, is something we have to contend with. But it is not something to despair about. It does not mean our activities are worthless because they will be co-opted.

YUILL There is also the issue of how, for many people nowadays; work life replaces 'home' life or locality in shaping an individual's sense of self. People increasingly structure their identity not so much in terms of where they are from, or their language or cultural commonalities, but in terms of their profession or job and the respective employment / employer. This

appears to be shaping out in two ways: one the one hand, it is leading to an increased sense of corporatism and the corporate 'mindset' as normative, on the other, there are signs of a trend in which employees are 'voting by vocation', and that people demand greater ethical responsibility on behalf of their employers as part of their pay deal. This seems like a ripe area for RTMark investment; considering projects like your promotion of national *Phone In Sick Day*. How do you respond to these trends?

GUERRERO Well, we think these sentiments are really dangerous, because they undermine social and democratic governments. It is great that people are demanding more ethical corporate behaviour as part of their pay, but unfortunately it also becomes a smokescreen for what amounts to corporations taking more and more power away from people. Laws should regulate corporate practices—because the corporate bottom line has no investment in the well-being of people.

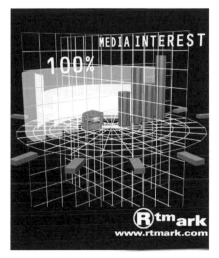

'Good corporate citizenship' is an oxymoron. We call it *greenwashing*. Here is a really weird example: after the World Trade Center tragedy last week, Wal-Mart announced it was going to hand out free American flags. The campaign was lauded as a gesture of good corporate citizenship. Anywhere outside of the USA, I am sure, it is clear that this is a totally opportunistic advertisement—and profiteering off the tragedy. But here people are lapping it up, excited that Wal-Mart is standing in solidarity with the war effort. Now that is good corporate citizenship.

YUILL A related trend is the rise of the ethical investor, RTMark are one example of an ethical investment company of sorts. Frank Zarb, of Nasdaq, talks about the idea of the 'citizen investor', which ties the growth of free capital to some kind of index of democratic development and promotes the idea that involvement in stocktrading is the most effective form of political engagement in today's world. It could be argued, at a certain level, that RTMark's 'activist investor' model confirms the 'citizen investor' hypothesis. To what extent do you think this might be true and where do these models part company? How would you summarise the differences?

GUERRERO Again, these are dangerous ideas that erode the notion of the public and the role of government as a tool of the people.

That is not to say that it is bad to engage in some notion of ethical investing. Clearly, we would not want to discourage this. And we also realise, that the realities of the US social services sector actually require people to invest if they want to live comfortably after they can no longer work. Therefore everyone who wants to live above the poverty line is required to invest, so why not do it ethically.

Just as boycotts are valuable, so is so-called responsible investing. But it cannot stand in for regulation. If you really want to be an activist investor, buy stocks so you can have a voice at stockholder meetings—spread the word to other investors.

YUILL A couple of your funds, CRPP and CRPD, are aimed towards bringing the whole issue of corporate legal status into question. If it were to be successful, what do you envisage the consequences of it being? Even if it were not successful, what other consequences do you anticipate?

GUERRERO Well, many of these projects and RTMark itself are simply

trying to focus attention on these issues. If RTMark is ever sued, we expect to lose, but we will turn the trial into a public spectacle that will focus the attention of the world on the issues we care about . . .

YUILL How is it progressing?

GUERRERO Well, nobody has sued us . . .

YUILL In terms of corporations undermining democratic and ethical governmental mechanisms, what do you see as some of the most critical developments?

GUERRERO One good example in the US is the case of Voting. Corporations in the US are allowed to spend limitless amounts of money on political advertisements because they have the rights of people—including freedom of speech, and a 1970s court case basically allowed all forms of advertising—no matter how expensive—to be considered free speech. So corporations can usher into office whomever they like . . . usually politicians who are willing to further de-regulate corporations. So the vicious cycle keeps amplifying itself. One of our sponsored projects, *Voteauction.com*, dealt with this very issue.

YUILL What models of post- or non-corporate politics are RTMark 'investmentors' supporting?

GUERRERO We are into a kind of socialism where the needs of people are balanced with the needs of the economy.

YUILL Certain commentators say that a return to 'traditional' democratic structures, based on the collective consensus of free-willed individuals, is no longer viable. The model of the centred, subjective 'self' has broken down and is likely to fragment further. The notion of legal personhood enjoyed by corporations could be seen as a factor in this. The Personal Roving Presences (PRoPs) project by the Experimental Interaction Unit is an ironic take on these issues in the business sector. What consequences do you see this having for social welfare and ethical issues, if going back to prior governmental and democratic structures is not possible? How can ethical concerns be implemented? Are NGOs the answer?

GUERRERO We still believe in many of the original notions of democratic and social governments—and we believe that by simply constricting what corporations are allowed to do, and by taking more of the money (uh oh, taxes!) and making them available to the poor and to social programmes, humanity will be better served.

YUILL An obvious comparison to RTMark would be AdBusters and MacLibel, and then there are groups such as Corporate Watch, and Übermorgen. At a world summit of non-corporations, whom would you like to see in attendance, and do you think the WTO would try to infiltrate it with a fake delegate?

GUERRERO If we did have an anti-corporate conference, I would hope that we could find participants that get a lot less attention and are a lot more effective than us. As for the infiltrators . . . we have already entertained various right-wing snoops on our mailing lists and discussion groups, so we would of course welcome one in real-life!

YUILL What is RTMark's response to events in New York and Washington and the growing war-drive? In the wake of an act of immense human tragedy we are seeing a battle being constructed between the 'reality' of American, and Western, individualism and a foe who is portrayed as

HOW IT WORKS

When trying to understand how a machine works, i helps to expose its guts. The same can be said of powerful people or corporations who work hard to make themselves richer— regardless of consequence for everyone else.

By catching powerful entities off-guard, you can momentarily expose them to public scrutiny. This way, everyone sees how they work and can figure ou how to control them. We call this *tactical embarrassment.*

In a Nutshell:

Find a target (some entity running amok) and think of something sure to annoy them—something that's also lots of fun.

If you're stumped, imagine the targe losing control and acting stupidly. What would i take to make them do that?

> *Journalists love fun stories, just like everyone else. The more fun the story, the more likely it is to get covered.*

Capitalize on the target's reaction. Write a press release and e-mail it to hundreds of journalists.

Preparing the Press Release

Imagine an "objective" newspaper story about the event. How would it read? Be realistic. Then write that story. (Got qualms? This is just what corporations do every day to sell products or candidates.)

Fishing for Cease and Desist Letters

The easiest way to embarrass someone powerful is to show how petty they are. Learn to embrace legal threats and use them as evidence in the court of public opinion.

A Few Highlights i Embarrassment History:

In 1967, Yippies threw a hundred one-dollar bills from a balcony onto the New York Stock Exchange floor. The journalists they'd brought along told the world how the brokers, consumed with greed, dropped their trading and scrambled around for the money.

Cost to Yippies: $100. Loss to NYSE due to shutdown: millions of dollars—not to mention their image.

http://gatt.org/yippies

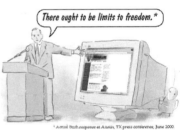

> *There ought to be limits to freedom.**

** Actual Bush response at Austin, TX press conference, June 2000*

During George W. Bush's run for President, ®™ark put up a website at GWBush.com tha looked just like Bush's campaign site, but tha poked fun of Bush and criticized the corporate funding of elections. When Bush saw the fake website, he got very angry and said some really stupid things on TV.

®™ark e-mailed press releases about Bush's behavior to thousands of journalists. The resulting press embarrassed the Bush campaign into withdrawing their legal threats as well as their complaint to the Federal Elections Commission.

Cost to ®™ark: $0. Bush was shown to be unbelievably whiny and capable of stooping very low when annoyed.

http://rtmark.com/bush

To highlight the Seville city govern-ment's "planned abandonment" of a centuries-old working-class neighborhood—a plan whose aim was to lower property values and make residents leave, thus paving the way for gentrification—activists planted thousands of altered city logos in the dog droppings that were filling their neighborhood. Visitors to an important conference on "sustainable cities" could not help wondering why the city was sponsoring dog shit.

REAL CITY LOGO

NO DO

"No me ha dejado."
You've never abandoned me.

ALTERED LOGO

SI DO

"Si me ha dejado."
You have abandoned me.

Cost to dogs: minor. Shortly afterwards, sanitation services resumed in the Alameda. More importantly, the gentrification plan was made more visible to all residents, and was shown to be everyone's problem.

http://www.sindominio.net/fiambrera

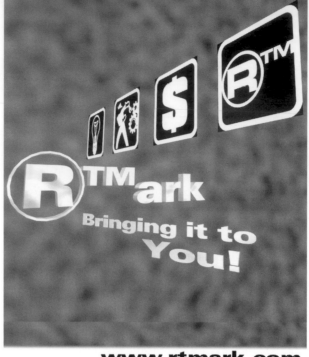

www.rtmark.com

being as ubiquitous, faceless and reductionist as Coca Cola. Noam Chomsky is urging that our response must be based on an understanding of its motives, which must involve a questioning of the West's involvement in the Middle East, whilst others are dressing this up as another brand war: Freedom Partners versus Terrorism Inc.

GUERRERO It is a tragic time to be an American. We are mourning the loss of five thousand people. But to respond to their loss as if we are part of a bad action movie devalues their lives. The responsible thing to do would be not only to try to identify and to bring to justice the criminals who did this—but also to understand why many people hate the United States, and to start enacting policy changes that are forward-looking, that are truly invested in being a good global citizen, and that are not directed towards shoving an American economic model down everyone's throat. It is sick. I agree with Chomsky . . . Unfortunately, our government here in the past three days, with almost no debate, has approved a whole bunch of measures that only make it easier to repeat historical mistakes.

The Art of 'Art Jockeys'

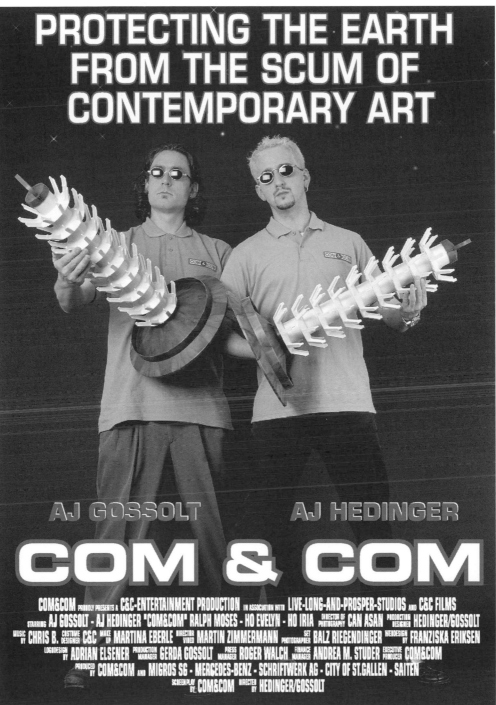

Protecting the earth from the scum of contemporary art
Postcard. 1997
Photo, grafix: Can Asan

Once we found each other, we knew we had a future.

COM & COM
in conversation with
Ute Tischler

COM & COM
founded in 1997 by
JOHANNES M. HEDINGER and
MARCUS GOSSOLT

JOHANNES M. HEDINGER
Artist, AJ (Art Jockey)
Born 1971 in Switzerland
Lives and works in Zurich, Switzerland

MARCUS GOSSOLT
Artist, AJ (Art Jockey)
Born 1969 in Switzerland
Lives and works in Zurich, Switzerland

UTE TISCHLER
Curator
Kunst- und Medienzentrum
Berlin-Adlershof, Germany
Born 1959 in Magdeburg, Germany
Lives and works in Berlin, Germany

C-Files:Tell Saga
Fancard, 2001

The following interview was held in February 2002. It took the form of an email discussion because, at the time, the Swiss artists MARCUS GOSSOLT and JOHANNES M. HEDINGER, COM & COM, were at their Egyptian holiday house at Sharm El Sheik whilst the Berlin-based curator,
UTE TISCHLER, was staying in Los Angeles, USA.

UTE TISCHLER You are on holiday on the Arab Peninsula. How are you?

COM & COM Fine. Actually, knowing that it is raining in Zurich at a mere 10
degrees Celsius, we are very well. Today we scuba dived in a spectacular canyon.

TISCHLER And now you are sitting on the hotel veranda with a bottle of wine and watching the sea with a content smile. At such moments you probably think: God, life is good to us.
(Two minutes pass)

COM & COM Yes. We are not quite sure yet though, if we do not have to pay
the bill one day.

TISCHLER You have worked in the advertising business for some time. Perhaps you know why so many people do not like ad(wo)men? You know the clichés: big mouth, sports car, constantly grinning and 'talking shit'.

COM & COM The problem with the cliches about ad(wo)men is, that they
unfortunately apply to too many of them. The reputation of the pleasant ad(wo)man (there are some, after all) is tainted by those unpleasant individuals. And the latter are more noticeable, because they set out to be noticed. The many bad advertisements do not help to improve the image of the profession either.

TISCHLER You said it bothers you that advertising is not regarded as a part
of culture. Do not you subscribe to a somewhat generous concept of culture?
(Seven minutes go by)
You are really taking time to think about that.

COM & COM Sometimes. But we have kept to our view.

TISCHLER Right, let us talk about the successful artists COM & COM. Art—book—film—theatre; do you succeed in everything you do?

COM & COM Everything we do, we try to do well rather than badly. It takes
the same amount of work, but it is more fun. However, do not believe that we succeed in everything. We simply tend to treat our failures more

Actually we have always been lucky.

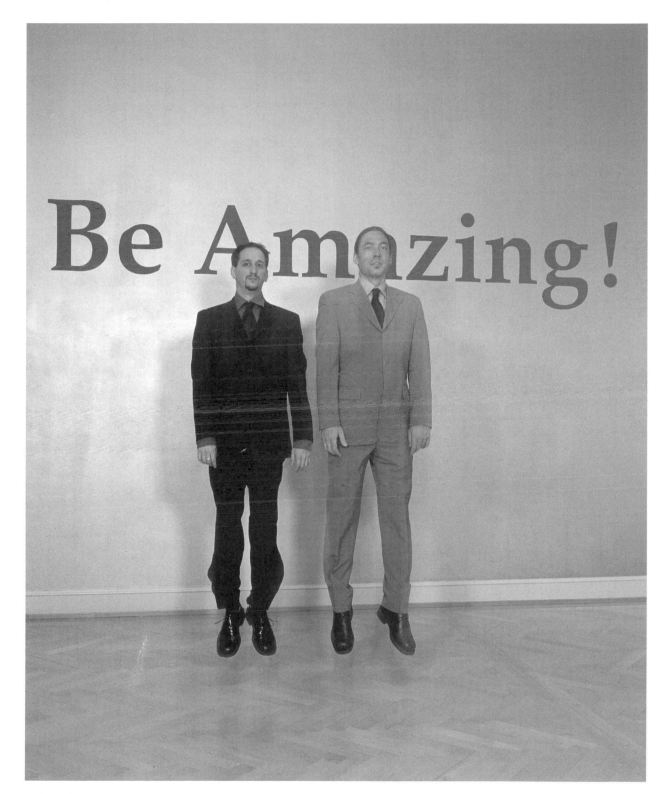

Amazing
Postcard, 2001
Photo: Stefan Rohner

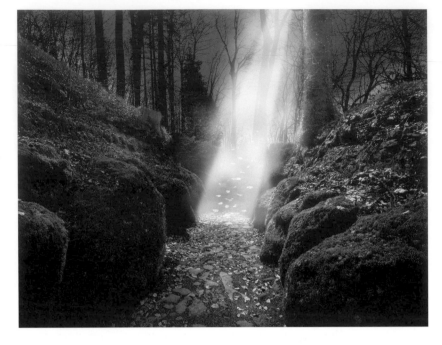

C-Files:Tell Saga,
The Valley (Hohle Gasse)
Photography, 1999
Photo: Stefan Rohner
Grafix: Can Asan

We're touching people's feelings.
That's the only thing that counts.

discreetly than our successes. You should see our drawers.

TISCHLER What will be your next large project?

COM & COM Until we dare to try our hands at that, a few suns will still have

to set on us. At the moment we use our time for less 'voluminous'
projects: small buns richly topped.

TISCHLER Do you have any artistic or other role models? To whom or what

do you pay attention?

COM & COM Yawn.

TISCHLER Nothing. I thought so.

COM & COM During an interview for a local television station in Berlin the

overexerted question was asked: 'What Swiss art do you like?' We
answered 'Füssli, Hodler and Fischli/Weiss.' Afterwards the following
question was cut into the arrangement: 'COM & COM, where do you
place yourselves artistically?' We replied: 'Füssli, Hodler and Fischli/
Weiss.'
And the reporter responded: 'That is perhaps a bit overestimated.'
We still have this tape.

TISCHLER That was really mean, almost like your art. In your art you excel

particularly in the disciplines of bluffing, lying, faking and copying. Today, uniqueness is not an ideal anymore but a stigma, which indicates one-dimensionality. One has to work with many voices—copied from the fathers, transposed into your own rhythm, your own temperature—and once that is mastered eventually, it is all about learning to link them organically.

COM & COM Our minds have gradually become able to easily imagine conditions of a passed era and consider the world through its own aesthetic view. We have discovered and put at our disposal the fourth dimension. History proposes the past, science fiction suggests the future. We are not a mere point on the line anymore, we are the whole line. To a polychrome time, one must react poly-morphously, if one wants to gain access to a work. Variety. A strong epigonal work of one hundred different masters is a thousand times more interesting than a genuine one that tries to lift the world all by itself. In the end it only colours the world with its own bloodstain.

TISCHLER All right, so much about the positioning of your art. What can be
said about general tendencies within the contemporary art scene? Do you also believe in the imminent fall of Occidental culture?

COM & COM There are always these culture-pessimistic lamentations, we cannot hear them anymore. ' . . . the nineties as the victory of bourgeois democracy, of capitalism, as a phase of sampling and recycling, of a lack of political experimentation, as well as of the increasing prostitution of culture.' We do agree with some of that and then again we do not. We are ourselves a symptom of these nineties, we do it for money too—an implicitness, which first had to be made presentable —and we still have got our souls. Furthermore, we carry with in us a counter-movement, developed by too much affirmation, which is probably the signet of the 'zero years'. Yet, an aggressive anti-capitalist culture is the last thing we miss at the moment. That could only be embarrassing after all.

TISCHLER Since we are on the topic: could you also say something intelligent about education policies? What should one be clued up about in the future?

COM & COM Science fiction, cinema and comics belong definitely more to
the cultural 'canon' than the alleged standard literature. On the other hand, to master old Greek and to play an instrument are definitely out. Specialisation is not necessary at all, as long as one eats enough from the remaining buffets. The range makes the difference. Or as Oscar Wilde said: education is something wonderful. From time to time, though, one should remember that the really valuable knowledge could not be taught.

TISCHLER Do you also mean traditional art education?

COM & COM Yes, there are not enough artists with surround horizons in this
country. Those that will not be slowed down by phenomena or will not be led astray or sweet talked by them, but—from one point in all directions—get through to the essence, to what resides beyond the fashion of the decade. One does not learn that in school, especially not in our art education institutions.

C-Files:Tell Saga,
The Forest (Wald bei Rütli)
Photography, 1999
Photo: Stefan Rohner
Grafix: Can Asan

We will never understand ourselves completely.

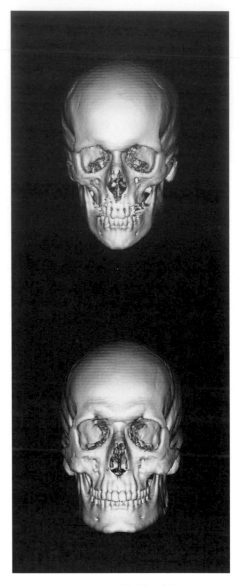

C-Files:Tell Saga
Poster, 2000
Photo: Stefan Rohner
Grafix: Can Asan

*Skulls of the artists,
Hedinger and Gossolt*

Postcards (abutted), 1999
*Computertomographie,
Grafix:* Can Asan

**Be arrogant and confident
even when you lose.
That's the secret:
courage and arrogance.**

The time is always right,
the question is only what for.

If you're in, you're in.
You're out again fast enough.

It's fantastic not to be loved –
it brings independence.

Maybe it's money that
makes us get up in the morning.
Everything else is work.

We are not artists, we are entertainers.
And if we're entertainers,
we might as well be the best.
COM&COM (Johannes M.Pfaltzgraf/Marcus Gossolt)

We knew it was going to make money
– but not like this!

At least once in your career
you have to be lucky.
The earlier the better.

Dictum 1 to Dictum 17
(shown on this page as well as on
previous and following pages)
Wallpaintings, 2001

TISCHLER A change of topic: what signifies a person with style?

COM & COM For one, the fact that s/he does not praise her/himself. Which makes it impossible for us to answer the question.

TISCHLER Since when are you so modest? Talking about money is known to be unsophisticated. I will do it anyway: your art is of fame and money.

COM & COM There is so much art, where money does not play a role. One never knows, from what those people live. Money is important in both life and art, but usually it is elegantly excluded in art or criticised. In our artistic work, we thematically and functionally occupy ourselves with economic and medial aspects within our culture and society. Our last, larger work 'C-FILES: TELL SAGA' quotes and uses the cross-mapping of mythology and Hollywood as well as the structures and aesthetics of a film advertising campaign—for many people that was already too much commerce and too little art. Here we hit the just-mentioned sore point: money should not be seen—and that does not just apply to art. Perhaps, that has also something to do with the Swiss mentality, which is keen on modesty and neutrality.

TISCHLER What role does money play in your private life?

COM & COM Money plays a role in our private life only to the extent that we cannot say it does not play a role.

TISCHLER The new peoples' sport is called stock trading. What papers could you recommend to me?

COM & COM Now, that is a bit too perverse for us, even we have a conscience. The same people, who lose their jobs during a fusion, force the companies to globalise. The same, who depend on the prosperity of Daimler Chrysler, for example, drive the courses of a virtual company like AOL so high, that AOL could theoretically—and maybe one day even practically—buy and ruin Daimler Chrysler. One rarely sees it that way.

TISCHLER I must say, I am astonished. How do you manage to have a halfway intelligent opinion about everything?

COM & COM We sit here at the table and see some camels in the dark sunset that colours the water of the Red Sea in even deeper ultramarine. On the hazy horizon, the reddish sand dunes of Saudi Arabia glow and the Muezzin calls to the evening prayer from the minaret.

TISCHLER How idyllic and far travelled. Please define the Swiss Bünzli for me.

COM & COM One cannot define the Bünzli quickly and he does not just exist in Switzerland. But if we must try: the Bünzli regards himself the measure of all things, and thus he measures the world accordingly. But look out: the Bünzli is subversive. For a long time now, he does not look anymore the way the Bünzli satire magazine *Nebelspalter* (Does that still exist?) once drew him. There are the pierced Bünzli, the tattooed Bünzli, the junkie-Bünzli, the media-creating Bünzli, the artistic Bünzli.

We have been making art for ten years.
But we always wanted to be Popstars.

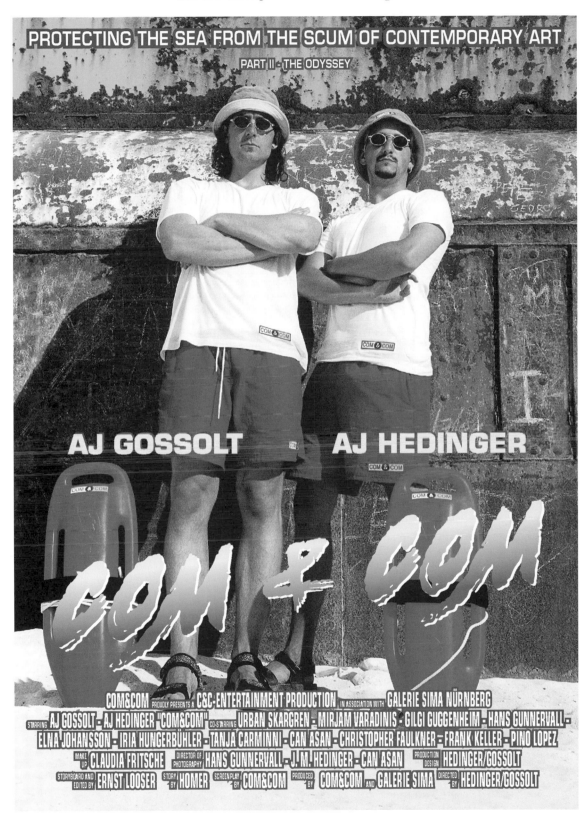

*Protecting the sea
from the scum of
contemporary art*

Postcard, 1998
Photo: Hans Gunnarvall
Grafix: Can Asan

Oh yes, the artist Bünzli!

TISCHLER Are you thinking of someone concrete?

COM & COM Oh yes! Definitely.

TISCHLER Perhaps we could also talk about the recent public uproar regarding the Flick-Collection established with Nazi money. Its collectors would like to build a museum for their collection in Zurich.

COM & COM Oh, not again! We are sick and tired of the sentimentality and

the pointed moral finger against the planned Flick Collection. Flick's money also flows into our tax collection, into our banks, and via his companies into our economy. It creates jobs, etc. Nobody ever raises their voice against those advantages. However—since art still has a moral claim—disapproval stirs. This disapproval surely also has to do with the fact, that once again a German comes along and sets himself a monument in Switzerland. People do not like that here. Yet, what about other war profiteers and arms suppliers like Swiss collector Bührle, who has built and equipped large sections of the Zurich Kunsthaus? These matters are not publicly discussed, since those individuals are part of 'us' . . . And of course, again and again, to buy dignified art with 'blood money' raises issues of morality and legitimacy.

TISCHLER So we are talking about 'art and morality'. The confluence of ethics and aesthetics.

COM & COM Morality can be an important aspect of the arts, but it is not

basically its first consideration. In most cases it is of the aesthetic kind. It is in different other forms of culture, such as literature, theatre, and in part of film. In our opinion, many artists lack the ability and/or will (or knowledge) to respond to issues of a moral nature. Direct communication with the public is being sought more frequently in the arts today (which potentially gives a greater scope for the articulation of moral issues), but if one takes a look at the art market: what, above all, is being bought? The aesthetic form. It is a naive dream to make something beautiful that is equally 'good' as well.

TISCHLER Apropos beauty: One could quickly mistake your new catalogue

for a fashion or a lifestyle magazine. Between us, how important is fashion to you?

COM & COM Let us say: Among the things that are not so important to us, it

assumes importance

TISCHLER Are you vain?

COM & COM Well . . . a little bit, surely. It has happened that we have changed our clothes after looking into the mirror.

TISCHLER Is there anything about women that you cannot stand at all?

COM & COM Trainers, jog pants and shirts. You know: those comfortable clothes you only wear at home. This brunch-look, the totally cosy. We cannot stand that with men either. And then, these colourful clothes, this homepage-look.

TISCHLER Is fashion art?

COM & COM It is more like a craft. However, artistic staging and pose are

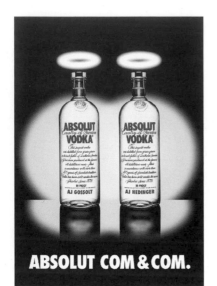

Absolut COM & COM
Postcard, 1998
Photo, Grafix: Can Asan

C-Files:Tell Saga,
The Lake (Vierwaldstättersee)
Photography, 1999
Photo: Stefan Rohner
Grafix: Can Asan

...one fine day we woke up...
...and found we were famous.

Camel
Postcard, 2000
Photo: Stefan Rohner
Grafix: Can Asan

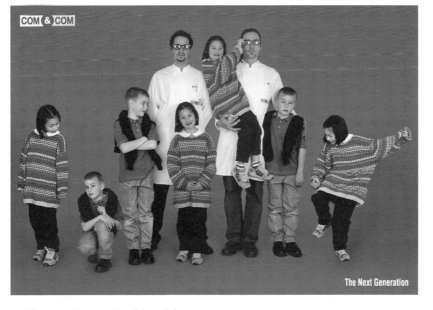

The next Generation (Family)
Postcard. 1998
Photo, Grafix: Can Asan

**Art is just
an episode.
Love is more.**

We don't care a shit what people say.

very important. In the end, they permit the designers to sell relatively normal clothes at relatively abnormal prices.

TISCHLER Is fashion a medication? I mean: does fashion have healing effects?

COM & COM It gives a certain security of not being completely 'out'/excluded. And it saves you from the agony of genuineness.

TISCHLER What is the difference between beautiful and genuine?

COM & COM Perhaps the beautiful is an inflation of the usual, while the genuine content itself is different from the usual? Perhaps that is also applicable to the arts?

TISCHLER Does a beautiful surface distract from the so-called 'inner qualities'?

COM & COM We believe the beautiful surface is an indication of how someone wants to be seen. And it does allow one to draw conclusions concerning their inner qualities. However, the possibilities of their expression are limited. One can rarely present oneself through fashion, but it does allude to where or what one wants to belong to.

TISCHLER The more short-term oriented a time is, the more it is aligned to
the fashion.

COM & COM We are not sure anymore, whether it is true, that fashion is more important today, than it was in the past. It is less elitist. Because many more people can afford fashion, it has become much more present. It is the same with salmon and champagne, oh: and probably art too. We all profit from the socialisation of luxury. And pay for it with bad quality. In fashion like in art: bad quality causes short-livedness. And at the risk of sounding like a wise guy: the omnipresence of fashion has perhaps to do with the fact that communication has become so important. Fashion has so much to do with communication.

TISCHLER Like your art too.

COM & COM Exactly.

TISCHLER The rejection of fashion is a constituent of fashion. Does that
also apply to the arts? Can one avoid art anyway?

COM & COM Indeed, here one can compare fashion and art. One can hardly
escape it. However, there have always been attempts to proclaim fashion or art dead with the slogan 'anything goes'. But designers and artists are not stupid. They make 'anything that goes' fashionable with a beautiful regularity, and, once again, the abolisher is trapped. Those who condemn fashion and art hate fashion and art likewise for their uselessness. They despise the passion for the useless and the artificial in general. Without passion for the purposeless, no culture develops.

TISCHLER Can one learn something by making art?

COM & COM To make art.

TISCHLER To make it better than other artists?

COM & COM No. To make art is not a competition. Art is not real life.

TISCHLER I do not believe you. What does 'real life' mean anyway? Good art
can put forward to its audience points of view, from which they can judge, from which values can be set.

COM & COM Well, that is a bit of a sore point. We have never liked seeing a
work of art and noticed that the artist wanted to teach us something about life and its values. An honest work of art (just as a book, a film or a

☐ **Jeff Koons**
☐ **Fischli/Weiss**
☐ **COM & COM**

Double Jesus
Postcard, 1998
Photo, grafix: Can Asan

*Protecting the world from the
scum of contemporary art*

Postcard, 1999
Grafix: Can Asan

Barclay
Postcard, 1999
Photo, grafix: Can Asan

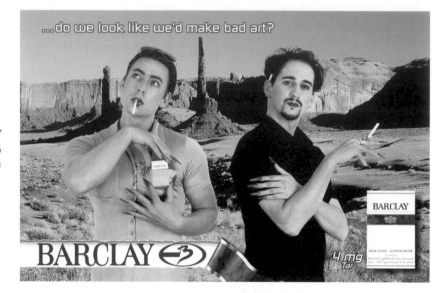

Meaningless Work—
Art as Abstract Labour

Person saying a Phrase
New Street, Birmingham, UK, February 2002

A person who was begging in the street was paid to say a phrase in front of a video camera.

The phrase was: 'My participation in this piece could generate profits of seventy-two thousand dollars. I am being paid five pounds'.

Notes on Santiago Sierra and the Political Economy of Man under Capitalism
Ross Birrell

SANTIAGO SIERRA

Artist

Born 1966 in Madrid, Spain

Lives and works in Mexico City, Mexico

ROSS BIRRELL

Artist and Lecturer

Glasgow School of Art, Scotland, UK

Born 1969 in Scotland

Lives and works in Glasgow

Person unremunerated to write six thousand words on Santiago Sierra

'To be a useful person has always appeared to me something particularly horrible.'

Charles Baudelaire

'You can make people do whatever you want if you pay the money. These are the working conditions in the whole world.'

Santiago Sierra

I

Ten people paid to masturbate
TEJADILLO STREET, HAVANA, CUBA, NOVEMBER 2000

One does it into his cupped left hand.

One does it into a tissue.

Unbuckled belts, unzipped flies or pulled down shorts. The same low stool and tiled floor in each.

Another uses a bit of spit to get things going.

One thinks he is a porn star, getting into it.

One does it balanced on his free hand behind his back.

One, with a slim chain around his wrist, holds up the leg of his shorts, pulls out his prick and gets to work.

One, just to get in the mood, injects a little violence. He gets off the stool and almost does it to the camera. A recalled or imagined rape. Fucking you right in the eye.

One uses two hands. He keeps going for a time but it is not happening. His penis flaccid, he sits back, folds his arms and refuses to continue.

One does it through the zipper of neat white shorts, left hand clutching his balls. A word, Pescara, is visible in block capitals on his hitched up T-shirt.

One does it with the twenty dollars still in his left hand, which rests before him on his knee. When he comes it is like completing a circuit. You get what you pay for. And this is what you paid for. The money shot.

II

In *The General Theory of Employment, Interest and Money* (1936), the economist John Maynard Keynes proposed a radical scheme. In times of economic depression, he suggested, it was possible to end unemployment

through adopting the principle of the remuneration of socially useless unproductive labour. What Keynes posed was that the Treasury fill old bottles with banknotes and bury them in the depths of disused coal mines. The mine shafts were then to be filled up with the ever increasing refuse produced by urban society. Invoking the principle of competitive tendering at the core of *laissez-faire* capitalism, Keynes then suggested a scheme whereby small businesses could make bids to local authorities for the contract to exhume the money which had been interred on council land. Forecasting that the whole process would serve to stimulate growth in the wider economy, Keynes argued that, by repeatedly paying workers to dig up buried banknotes, the state could provide an economically viable solution to the socially unstable problem of mass unemployment. It may have been more sensible, conceded Keynes, to pay workers to engage in socially useful productive labour (such as the building of much needed houses or hospitals), but if this could not or would not be done then, he reasoned, the government should adopt the strategy of paying men wages to carry out socially useless and unproductive labour. Due to the obvious financial benefits to workers and the concomitant contribution to the economic well-being of the state, Keynes concluded that the remuneration of meaningless work was better than nothing.

III

The wall of a gallery pulled out, inclined sixty degrees from the ground and sustained by five people
GALLERY ACCESO A, MEXICO CITY, APRIL 2000

Over time it starts to take on its own rationale. Holding up the wall, getting the angle right. Keeping the whole thing from falling while someone adjusts their hands or feet. Sometimes it is just to keeping the blood circulating, arms heavier than the wall eventually, sometimes it is to go for a piss. A ladder acts as a makeshift safety net. Occasionally heads replace hands as supports, shifting your body closer to the wall, keeping your balance raising and lowering your centre of gravity in response to the rhythm of bodies spread out along the wall. It is back-braking work, but you are just following instructions. Bending your body to the demands of the wall.

IV

The concept of 'unproductive labour' was first outlined one hundred and sixty years before Keynes made his modest proposal, by the Scottish economist and philosopher Adam Smith (1723–90). In Book II of *The Wealth of Nations* (1776),[1] Smith explains:

> There is one sort of labour which adds to the value of the subject upon which it is bestowed: there is another which has no such effect. The former, as it produces a value, may be called productive; the latter, unproductive labour. Thus the labour of a manufacturer adds, generally,

The Wall of a Gallery pulled out, inclined Sixty Degrees from the Ground and sustained by Five People
Acceso A Gallery. Mexico City.
April 2000

1. Adam Smith, *The Wealth of Nations* edited by Andrew Skinner, Harmondsworth, Penguin, 1970, pp. 429–430.

2. *Ibid.,* pp.430–431.
A known defender of his friend and fellow countryman, the atheist David Hume, Smith received hostile responses from the clergy for this passage upon unproductive labour. Marx notes that: 'Parson Thomas Chalmers was inclined to suspect that Adam Smith invented the category of "unproductive labourers" out of pure malice, so that he could put the Protestant parson in it, in spite of their blessed work in the vineyard of the Lord.' Karl Marx, *Capital: A Critique of Political Economy, Volume 1,* Harmondsworth, Penguin, 1973, p.768.

Arguably, we could also add the labour of the prostitute to this inventory of unproductive labour. Like the actor, orator, or singer, the work of the prostitute (and the masturbator) 'perishes in the very instant of its production'. For Sartre, this auto-destructive condition is also the economy of criminality. 'The criminal,' he writes, 'dies at the moment of the crime.' Jean-Paul Sartre, *Saint Genet: Actor and Martyr* translated by Bernard Frechtman, New York, Mentor, 1963, p.202.

It is interesting that, for Sartre, Jean Genet, as criminal and masturbator in prison, also invokes a parallel between the condition of the unproductive labour of masturbation and the economic condition of a king: 'Genet jerks off at the taxpayer's expense; that increases his pleasure. If he so often compares prison to a palace, it is because he sees himself as a pensive and dreaded monarch, separated from his subjects, like so many archaic sovereigns, by impassable walls, by taboos, by the ambivalence of the sacred. He returns to it often: the repressive apparatus has been set up for him; the cops and judges are at his disposal; the Black Maria is a triumphal chariot; for whom, if not for this royal dreamer, do their tires wear out, is their gasoline consumed? A large staff of servants is concerned exclusively with him: the turnkeys are his guardians and his Guard; what would they be without him.' Sartre, p.400.

to the value of the materials which he works upon, that of his own maintenance, and of his master's profit. The labour of the menial servant, on the contrary, adds to the value of nothing.

Labour is productive essentially when it is engaged in the production of the 'vendible commodity' for consumption on the market, the exchange value of which will normally be determined in relation to the labour costs involved in manufacture. Labour is unproductive when it produces no vendible commodity, but which is paid for on account of the value considered to exist in the process of labour itself. Thus, Smith concludes, the labour of the most menial servant is akin not only to that of the monarch and the politician (as public servants), but also to that of the philosopher and the performing artist:

The labour of some of the most respectable orders in society is, like that of menial servants, unproductive of any value, and does not fix or realise itself in any permanent subject, or vendible commodity, which endures after that labour is past, and for which an equal quantity of labour could afterwards be procured. The sovereign, for example, with all the officers both of justice and war who serve under him, the whole army and navy, are unproductive labourers. They are the servants of the public, and are maintained by a part of the annual produce of the industry of other people. Their service, how honourable, how useful, or how necessary soever, produces nothing for which an equal quantity of service can afterwards be procured. The protection, security, and defence of the commonwealth, the effect of their labour this year, will not purchase its protection, security, and defence for the year to come. In the same class must be ranked, some of the gravest and most important, and some of the most frivolous professions: churchmen, lawyers, physicians, men of letters of all kinds; players, buffoons, musicians, opera-singers, opera-dancers, etc. The labour of the meanest of these has a certain value, regulated by the very same principles which regulate that of every other sort of labour; and that of the noblest and most useful, produces nothing which could afterwards purchase or procure an equal quantity of labour. Like the declamation of the actor, the harangue of the orator, or the tune of the musician, the work of all of them perishes in the very instant of its production.[2]

For both Smith and Keynes, the character of 'unproductive labour' is to 'produce nothing' in the form of vendible commodities, and have no economic afterlife beyond the immediate performance of their labours. The essential difference between the unproductive labour posited by Keynes and that characterised by Smith, however, centres around the distinction of whether or not the labour is deemed 'socially useful' or 'socially necessary'— a factor crucial in underpinning Marx's theory of the remuneration of the use-value of labour. Whilst it is possible for Smith to regard the unproductive labour of lawyers, philosophers, and clergymen and even that of actors, musicians and entertainers as performing some socially useful or necessary 'public service', and that they thereby exhibit a 'purposive

rationality',[3] for Keynes the 'purposive rationality' lies in the final aim of the proposal—to end unemployment—and not in the logic of the work actually carried out, which is essentially meaningless and repetitive. In itself, the labour performed in Keynes' proposal can be considered neither socially useful nor socially necessary. Subsequently, Keynes' unproductive labour can make no palpable claim to 'rationality of purposive activity' in a society based upon productive labour. It would seem that in a capitalist society, organised around the production paradigm, the visual display of useless labour is preferable to paid unemployment. Although it could be argued that the unproductive labour Keynes' suggests might seek to perform the 'socially useful' function (in a period of Hunger Marches which followed in the wake of the 1929 stock market crash) of averting a potentially revolutionary situation of mass unemployment, the Swiftian logic of his modest proposal threatens the 'inherently purposive rationality' of the concept of labour in favour of an 'aesthetics of production'.[4] In other words, in Keynes' view, it may be legitimate to remunerate men for purposeless, unproductive labour as long as they are 'seen' to be working. What Keynes is forwarding, in effect, is objectified unproductive labour as a mirror of production. Thus, perhaps unwittingly, Keynes' proposal challenges the production paradigm at the very core of capitalism as it has been understood and explained by theorists from Adam Smith to Karl Marx.

For his part, Marx understood the use-value and the exchange-value of labour, its value as a commodity and its remuneration by money, as a consequence of the degree to which its performance is regarded as 'socially useful':

> The product of a worker's labour serves him solely as exchange value. But it can only acquire universal validity by being converted into money. That money to reach the worker (since it is usually in someone else's pocket) must be exchanged for a labour which is use-value for the owner of the money. The labour expended on it must therefore be of a socially useful kind—it must maintain its position as a branch of the social division of labour . . . [5]

The performance and remuneration of unproductive, socially useless labour proposed by Keynes therefore mounts a challenge both to the production paradigm of capitalism and the concept of a socially useful labour valued by Marx. It is just this kind of socially useless unproductive labour which is foregrounded in the recent series of remuneration actions by the Mexico City-based artist, Santiago Sierra.

V

Workers who cannot be paid, remunerated to remain inside cardboard boxes

KUNST-WERKE, BERLIN, SEPTEMBER 2000

This work is an adaptation of those created in Guatemala and New York, where workers were placed inside cardboard boxes under different

3. Jürgen Habermas, *The Philosophical Discourse of Modernity: Twelve Lectures* translated by Frederick Lawrence, Cambridge, Polity Press, 1990.

4. *Ibid.,* p. 66.

5. Karl Marx, *Op. cit.,* p. 65.

circumstances. In this case, six workers remained inside the boxes for four hours a day for six weeks, having to collect their salaries in secret because of their status as political exiles. German legislation gives an exiled person eighty DM, about forty dollars a month, and prohibits that s/he works under the threat of returning them to their country of origin. Therefore, the details of this piece could not be made public at the time. The refugees came from Chechnya.

VI

Sierra gained notoriety through a series of audacious actions interrupting the organisation of striated capitalist social space, such as his *Obstruction of a thoroughfare with a trailer truck,* in which a white trailer truck was jack-knifed on *La autopista de la Amistad* (The Motorway of Friendship), Mexico City, 1998. Or his apparent assault on the values of the art world, as in *Gallery burned with gasoline* (Art Deposit Gallery, Mexico City, November 1997) which consisted of igniting a newly refurbished gallery space with gasoline on the opening night. Yet it is with his recent series or remuneration actions—in which the artist pays refugees, illegal workers, migrant labourers, day-labourers, prostitutes or homeless people, who are mainly African, Asian and Hispanic, to perform absurd, repetitive, banal, arduous, meaningless tasks—which is the focus here.

The labour performed in Sierra's remuneration actions is neither socially useful nor productive. Nor does it provide participants with social purpose—a factor which functions historically as the basis from which to articulate stable individual or collective identities. Rather, identity, individual or collective, is numbed through the performance of abstracted meaningless tasks. For example the work *The wall of a gallery pulled out, inclined sixty degrees from the ground and sustained by five people* (Gallery Acceso A, Mexico City, April 2000): 'A wall installed in the gallery was pulled out from its place and during four hours, for five days, five workers acted as buttress to keep it at sixty degrees from the ground. Four of them held the wall while the fifth checked that the inclination was correct. For the five working days, each worker earned seven hundred pesos, about sixty-five dollars.' In another work, *250cm line tattooed on six paid people* (Havana, December 1999) a line of Hispanic young men stand with their faces to a wall, their back's exposed to the gallery, a minimalist single line tattooed across their shoulder blades. In *465 Paid People* (Museo Rufino Tamayo, Sala 7, Mexico City, October 1999) a group of Mexican civilians were crowded into a small gallery space, a few spilling out into the corridor. The works all have the same simple self-explanatory titles: *Ten people paid to masturbate* (Havana, Cuba, 2000), *Eight people paid to remain inside cardboard boxes* (G&T Building, Guatemala City, August 1999), *A person paid for three hundred and sixty continuous working hours* (P.S.1, New York, 17 September–1 October 2000). Measurement is also dominant, as in *Car raised 100cm* (Mexico City, August 1998), *Object measuring 600 x 57 x 52cm constructed to be held horizontally to a wall* (Zürich, April 2001) and *Line measuring 200cm scratched into a car's paint* (Olbia, Sardegna, July 2001). This principle is most movingly displayed in the works which consist of straight lines

tattooed down or across people's backs, such as *250cm line* as well as *Person paid to have 30cm line tattooed on them* (Mexico City, May 1998) and *160cm line tattooed on four people* (Salamanca, Spain, December 2000). These remunerated actions painfully articulate the condition of people at the mercy of discourses which confine and define the human subject along rationalist and quantitative principles.

In Sierra's words, the basic concept behind the remuneration action is an operation which involves 'the application of an unnecessary technical activity which is also inappropriate to the methods commonly used'. The overall effect is that of looking into a distorted mirror of production which provides an often humorous, even grotesque, reflection of the alienated conditions of labour under capitalism. In a manner which echoes Keynes' disruption of the logic of socially useful, productive labour and which denies the 'purposive rationality of goal-directed action' (Habermas, p.67), Sierra's remuneration actions simulate the conditions of manual work in an aesthetics of labour, whilst their performative modality suggests an ethics of play. As such, these actions are often provocative and absurd essays on the barbaric conditions of cheap immigrant labour which perform timely, perhaps critical, interventions into the discourse of globalisation. Yet as 'nihilistic activities, without a precise goal' the remuneration actions can also be seen to flow from the tradition of minimalist and Fluxus performance, the avant-garde milieu which produced Walter de Maria's 1960 manifesto *Meaningless Work* in which was claimed: 'Meaningless work is obviously the most important and significant art form today.'[6]

In looking at the photographs of the young Cuban men in the documentation of *250cm line* we may think of the minimalism of Piero Manzoni's *Lines*, a parody of the artist's labour in an age of production lines and serial production, or his marker pen signing of nude female models as *Living Sculptures*. In Sierra's case, however, the tattoo is a less playful engagement with a similar territory: it is a brutal line of production. The tattooed line is not a signature, it is an effacement of individuated identity. Its closest approximation is the branding of slaves. Similarly, the four hundred and sixty-five Mexican men crammed into the gallery space, subject to the gaze of the privileged viewer may resemble the scene of a slave market or livestock huddled into a pen. Overwhelmingly, we are faced with an image of the worker as commodity. In effect, Sierra commodifies the social conditions of his African, Hispanic and Asian male and female participants, exploits their life-process-as-labour-process, not in order to extract profit (although he has achieved international recognition in the art world), but to exploit their ambiguous or contradictory status as signs, as their marginalised identities are reflected and refracted through the complex contexts of global capitalism.

Yet his strategy of remuneration remains ambiguous and unaligned. As a cancer cell mirrors a healthy cell in order to spread unhindered through the body (whereby the body actually contributes to keeping the cancer alive), Sierra expands his critical art operation through the high cultural institutions of capital. In effect, Sierra employs these men at the level of menial servants described by Smith: their labour does not result in the production of vendible commodities, their labour alone is the commodity which they produce. What is transformed into a commodity through Sierra's

6. This manifesto, dated March 1960, first appeared in La Monte Young (ed.), *An Anthology*, New York, George Maciunas and Jackson MacLow, c.1962. Reprinted in Kristine Stiles and Peter Selz (eds), *Theories and Documents of Contemporary Art: A Sourcebook of Artists' Writings*, Berkeley, University of California Press, 1996, p.526.

remuneration of the time of his participants, however, is not simply their labour-power as such but their ability to function/perform as signifiers of certain conspicuous identities (migrant workers, asylum seekers, the African-Asian non-European other) as determined by their specific cultural situation in certain socio-economic conditions and geo-political contexts.

VII

A person paid to clean visitors shoes without their consent during an opening
ACE GALLERY MEXICO, MEXICO CITY, MARCH 2000

In Mexico City's subway system it is common to find young boys and girls dragging themselves on the floor to clean other people's footwear, without their consent, in order to earn a tip. They search for a reward or compensation in the potential client's compassion rather than in the effectiveness and need to polish shoes. For this occasion a boy of about eleven years of age is taken to an opening of an exhibition of photography where he carries out his usual job.

VIII

Sierra's series of remuneration actions playfully and critically correspond to the traditional division of labour in factory assembly-line production: alienating, repetitive tasks, a condition in which it makes no difference what you do as long as you get paid. Sierra has stated about the men he paid to hold up the wall: 'From the point of view of the worker, there exists no difference between the utility or uselessness of [their] efforts while their time is remunerated.'[7] Yet, in his relationships with his employees, it could be argued that Sierra adopts the camouflage of a small-businessman, as employer and exploiter, in order to foreground capitalist inter-human relationships in their naked state. As Ernest Mandel argues:

> From the point of view of the single capitalist firm, a worker cannot be seen as a human being endowed with elementary rights, dignity, and needs to develop his personality. He is a 'cost element' and this 'cost' must be constantly and exclusively measured in money terms, in order to be reduced to the utmost. Even when 'human relations' and 'psychological considerations' are introduced into labour organisation, they are all centred in the last analysis upon 'economies of cost'.[8]

Capitalism, Mandel asserts, brutally crushes the spirit of workers through 'the tyranny of meaningless, mechanical, parcelled work',[9] and has the power to organise, exploit, degrade and denigrate man's needs to the extent that man is subjected to the dehumanised condition of commodification and alienation. This is the situation which Jürgen Habermas has referred to as the 'ruptured ethical totality' of alienated labour.[10] The emasculating condition of alienated labour is a result of the capitalist reduction of the

7. http://www.laneta.apc.org/curare/ cuau16htm&prev=search%3Fq% 3D%2B%2552Santiago%2BSierra% page 3.

8. Karl Marx, *Op. cit.*, p.65. Mandel's argument may be little more than a Marxist rehearsal of the familiar argument that 'everything has its price', or the adage that 'time is money' (as, inevitably, time also becomes a commodity in a profit-driven, segmented, automated, industrial economy). It may also simply reiterate the cultural condition of capitalism, which Oscar Wilde famously states as 'knowing the price of everything and the value of nothing'.

9. *Ibid.*, p.72.

10. Jürgen Habermas, *Op. cit.*, p.65.

sphere of human interests to the accumulation of commodities and the maximisation of profit. Mandel concludes: 'Capitalist economy is thus a gigantic enterprise of dehumanisation, of transformation of human beings from goals in themselves into instruments and means for money-making and capital accumulation.'[11] The ultimate signifier of capital, therefore, is money.

In short, Sierra's series of remunerated actions embody Georg Simmel's consideration of money as a reification of the general form of existence. In *The Philosophy of Money* (1907), Simmel wrote:

> [M]oney represents pure interaction in its purest form; it makes comprehensible the most abstract concepts; it is an individual thing whose essential significance is to reach beyond individualities. Thus, money is the adequate expression of the relationship of man to the world, which can only be grasped in single and concrete instances, yet only really conceived when the singular becomes the embodiment of the living mental process which interweaves all singularities and, in this fashion, creates reality.[12]

Simmel also considered manual labour to be the 'ultimate concrete element of labour'[13] and nowhere is this principle more manifest in Sierra's remuneration actions than in *Block of concrete constantly moved during a day's work by paid workers* (ACE Gallery L.A., Los Angeles, July 1999), where ten men were paid to keep moving twenty concrete blocks, each weighing two tons, using only metal bars as handles. Thus Sierra's remuneration actions seek to intensify capitalism's dehumanising and depersonalising relationship to the worker in order to accentuate current levels of economic oppression. The process of depersonalisation, or rather of reducing individuals to anonymous 'persons', is also reflected in the summary aspect of Sierra's titles which merely provide an inventory of the actions performed. The flat inventory character of Sierra's titles may provide an indication the condition of human relations in 'the functional context of modern society organised upon the production paradigm'.[14] Yet in the gallery the workers are no longer simply labourers, they become the objectified appearance of labour, mirrors of production. They also become subject to the discourse of the art world. As Garcia-Antón writes: '[Sierra's] use of people as ready-mades in the series of remunerated activities pushes at the limits of sculptural possibility'.[15] Mirroring the objects of Chardin still lifes, the participants in Sierra's actions are transformed into 'mere accessories' and 'servile vessels of appearance'.[16] In effect, through his remuneration actions, Sierra paints globalisation as still life.

IX

Blocks of concrete constantly moved during a day's work by paid workers
ACE GALLERY L.A., LOS ANGELES, JULY 1999

The sweltering dry heat and dust must have made the work almost unbearable. Ten Mexican or Central American day labourers have moved the

11. Karl Marx, *Op. cit.*, p.65.

12. Georg Simmel, *The Philosophy of Money,* ed. by David Frisby, trans. by Tom Bottomore and David Frisby from a first draft by Kaethe Mengelberg, Second Enlarged Edition, London, Routledge, 1978 (1990), pp.129–130.

13. *Ibid.*, p.418.

14. Jürgen Habermas, *Op. cit.*, p.73. Adam Smith's observation of the total manufacture involved in clothing and accommodating 'the most common artificer or day-labourer' is an excellent articulation of the inventory character of the production paradigm of capitalist social relations. See Smith, pp.115–117.

15. Katya Garcia-Antón, 'Buying Time', in: *Works 2002-1990,* Birmingham, Ikon Gallery, 2002, p.17.

16. Frédéric Paul, 'Aernout Mik Confusing sensation', AM-III, *Post-Nature: Nine Dutch Artists,* Eindhoven, Stedelijk Van Abbemuseum and Biennale di Venezia, 2001, np.

In many respects, the summary nature of these titles have much in common with those of the Dutch artist Aernout Mik. Paul has likened the titles of Mik's video works, such as *A Small Group Falling* and *3 Laughing and 4 Crying* (both 1998) to the titles of still life paintings by Chardin: 'If we read the title, *Pears, Walnut and Glass of Wine* (1768), we don't learn a thing, to the point that we're almost astonished. The title does nothing more than passively repeat an inventory of the same accessories brought together by the artist to make the painting. The relationship is flatly objective. So objective that the link between work and title becomes tautological... The title *3 Laughing and 4 Crying* can be taken as a pastiche of these kinds of customary titles, given for practical reasons . . . The title evokes the conflict between work and inventory. It also transforms living characters into mere accessories, servile vessels of appearances: the inert element of a still life, for instance.' The objective, tautological and inventory character of Mik's titles is also present in Sierra's remuneration actions.

twenty-four concrete breakwaters, 250 x 150 x 100 cm, weighing two tons each, around the spaces and corridor of the gallery. No consideration is given to damage done to the surfaces and walls. Once completed the residue of a day's hard labour—metal bars, bricks, empty plastic coke bottles, food bags and paper cups—are simply left as evidence. The main gallery looks like a large-scale Beuys installation, but there is no redemptive experience to be found in the metaphysical nature of materials here. Only the abandoned signs of physical labour.

X

In his 1965 essay 'Art as Concrete Labour: Aesthetic Value and Exchange Value', Adolfo Sánchez Vázquez outlines the conditions of abstract labour: 'In its abstract form, labour is conceived in its generality, as a universal process "in which the individuality of the worker is erased".'[17] As essays on the depersonalised conditions of *concrete* labour, Sierra's remuneration series also comment upon the condition of *abstract* labour. 'Labour time thus conceived is also an abstraction of particular concrete time, which can be greater or lesser than the amount of socially necessary labour time.'[18] The labour performed in Sierra's installations is not therefore concrete, individual and qualitative. Rather it is performed quantitatively, as a fragment and fraction of the universal condition of abstract labour.[19] But what is *produced* in this performance of abstract labour? Might the unproductive labour involved in these works articulate Habermas' understanding of the 'obsolescence of the production paradigm' where the paradigm of production 'loses its plausibility with the historically inevitable end of a society based upon labour'?[20] Or, more likely, might Sierra's remuneration actions openly challenge such academic assertions as 'the historically inevitable end of a society based upon labour'? Possibly, Sierra foregrounds the principle of remunerated labour in order to provoke the necessity of envisioning a different system of values, a society beyond economic determinants in which the mirror of production would be smashed. But the nihilism of Sierra's remuneration actions and his own comments may condemn such a reading as hopelessly utopian:

> I can't change anything. There is no possibility that we can change anything with our artistic work. We do our work because we are making art, and because we believe art should be something, something that follows reality. But I don't believe in the possibility of change. Not in the art context, not in the reality context.[21]

XI

250 cm line tattooed on six paid people
ESPACIO AGLUTINADOR, HAVANA, DECEMBER 1999

Six unemployed young men from Old Havana are hired for thirty dollars to agree to be tattooed.

17. Adolfo Sánchez Vázquez, *Art And Society: Essays in Marxist Aesthetics*, London, Merlin, 1973, p.191.

18. *Ibid.,* p.192.

19. The most obvious example of an artist to engage openly in the sign-value of the abstract performance of labour in the context of art is, of course, Andy Warhol. Warhol's transformation of the artist's studio into his *Factory* and the stylised referencing of the division of labour in assembly-line construction, serial-production and consumption throughout the 1960s, re-positioned the artist-as-producer in capitalist culture in a way which rendered obsolete attempts by Marxist critics, such as Sánchez Vázquez, to resurrect an idyllic, pre-division of labour, aesthetics of artistic production.

20. Jürgen Habermas, *Op. cit.*, p.79.

21. Katya Garcia-Antón, *Op. cit.*, p.21.

250cm line Tattooed on Six Remunerated People
Havana. December 1999

XII

Durational performance actions by artists like Chris Burden or Tehching Hsieh spring to mind in the P.S.1 work, *A person paid for three hundred and sixty continuous working hours,* where Sierra paid a person to remain behind a brick wall constructed to cut diagonally across the second floor of the gallery. Here unproductive labour, as both mirror and challenge to the production paradigm of capitalist social relations is given, perhaps, its most violent articulation. The anonymous 'person' of the title, whose job it was to live behind the wall twenty-four hours a day for fifteen days, was Rafael Perez. Given no responsibilities or duties to perform, only a fee of $5,000 (approx. £10 per hour—although it is not clear whether this was before or after tax), Perez was free to fill his three hundred and sixty consecutive hours behind the wall in any way he chose. Quite simply he was paid to do nothing. In any other circumstances this would be everyone's utopia. Yet in this context, the exchange becomes threatening as, like a prisoner in solitary confinement or an animal at the zoo, Perez was fed each day by gallery staff through a narrow aperture at the base of the wall. The presence of the wall cut across the gallery space performs as a visceral barrier between two spaces and experiences: work/play, freedom/confinement, activity/inactivity, inside/outside, concrete/abstract labour, self/other, signifier/signified, etc.[22] Each of these binaries is held in suspension in Sierra's installation. Sierra does not simply set up binary oppositions in order to critique or cement cultural relations. Rather, an ambiguity is at play on both sides of the wall. If Perez is alienated from his labour (work) then he is alienated equally from his leisure (non-work), play. Behind the wall, the lack of 'substantive content'[23] to Perez's freedom renders it negative. Perez time is neither structured (apart from meal times), nor separated into labour/leisure. He is in continuous paid unemployment, performing neither work nor non-work. Invoking Herbert Marcuse, Jean Baudrillard argued in *The Mirror of Production* that forced free-time, in the order of non-work which Perez performs, is only the 'repressive desublimation' of labour, merely a mirror of alienated production:

> The end of the end of exploitation by work is this reverse fascination with non-work, this reverse mirage of free time (forced free-time, full time-empty time: another paradigm that fixes the hegemony of a temporal order which is always merely that of production). Non-work is still only the repressive desublimation of labour power, the antithesis which acts as the alternative.[24]

The wall is both disjunctive bar and mirror. It divides and reflects. Further, through making Perez invisible, Sierra renders visible the concealed conditions of labour in the production of all commodities.

22. In other words, the wall functions in a similar fashion to the conceptual bar 'whose function is to draw and to maintain critical distinctions . . . [and] . . . in semiological and structural analysis which holds basic concepts and relations together and keeps them apart'. Gary Genosko, *Baudrillard and Signs: Signification Ablaze,* London, Routledge, 1994, pp.1–2. It is this disjunctive bar which serves to separate and bind binary structural oppositions between which the viewers of Sierra's installation oscillate. Yet, as Lyotard has written, the bar demands its own transgression 'since in order to demarcate this side from that, one must be on both sides'. Jean-François Lyotard, 'For a Pseudo-Theory', tran. by Roshe Mon, *Yale French Studies 52,* pp.115–127, quoted in: *Ibid.,* p.1.

23. Georg Simmel, *Op. cit.,* p.402.

24. Jean Baudrillard, *The Mirror of Production,* transl. by Mark Poster, St. Louis, Telos Press, 1975, p.40.

XIII

Two maraca players
GALERÍA ENRIQUE GUERRERO, MEXICO CITY, JANUARY 2002

Two blind people, who are usually found begging in the streets downtown, were hired to carry out their job in the gallery. Although their working day is usually more extended, they were hired to play four hours per day during a month. Finally, the gallery encouraged them to play only when a visitor arrived. Six loudspeakers were used to amplify their sound.

XIV

In the work produced for the opening of the Fiftieth Venice Biennale, *Persons paid to have their hair dyed blonde* (Venice, June 2001), in which approximately two hundred (the exact number is uncertain) of the Senegalese, Chinese, Bangladeshi, and Southern Italian street sellers in the narrow streets off the Piazza San Marco were paid 120,000 lire to have their hair dyed blonde, Sierra plays with the conditions of visibility and invisibility of illegal labour. This simple social activity of dying the participants black hair the colour of straw, heightened their social visibility whilst making invisible their status as individuals, simultaneously seeming to erase and articulate racial and cultural difference. (Like the tattoo actions, the dying of hair was inspired by the marking of illegal immigrants by many border police in order to prevent them from blending into local immigrant populations). Their status as 'fake' Caucasians seemed to parallel the status of the fake commodities (Gucci handbags, etc.) which many of the men peddled to tourists to make a living. Ultimately, like the unproductive labour of Perez in P.S.1, the men in Venice were engaged in a kind of 'fake' work: neither work nor non-work. In effect, the work of socially useless unproductive labour produces nothing but itself, engaged, as it is, in a narcissistic libidinal economy—a factor perhaps most potently illustrated in his video of a group of Mulatto men paid to masturbate before the camera (a work which perhaps collapses the suggested distinction between performing monkey and 'organ grinder').

Although Sierra is principally focused upon non-white manual labour, in his objectification of his participants it could be argued that, for all the 'manly' qualities of the historical associations of labour, he is, in effect, 'feminising' these participants in articulating the performance of their labour as prostitution.[25] With neither the freedom to act, nor the opportunity to express their will, the workers in Sierra's remuneration series are cast as objects in a system of values and not subjects in a drama. Yet the demonstrable 'reality' of the economic transaction, does not necessarily determine an absence of 'theatricality'. The money which changes hands is only so much make-up, the simulacrum of exchange; the labour is ultimately masquerade. As a result, these men and women enact a kind of 'transvestite' labour: unproductive labour as neither work nor non-work. 'Neither homosexuals nor transsexuals,' writes Baudrillard, 'transvestites like to play with the indistinctness of the sexes.'[26] Similarly, Sierra's remunerated

25. William Morris, for example, invokes the 'manly' aspect of useful labour: 'There are two kinds of work, one good, the other bad; one not far removed from a blessing, a lightening of life; the other a mere curse, a burden to life.

What is the difference between them, then? This: one has hope in it, the other has not. It is manly to do one kind of work, and manly to refuse to do the other.' William Morris, 'Useful Work versus Useless Toil' (1884–5), Paul Greenhalgh, *Quotations and Sources on Design and the Decorative Arts*, Manchester: Manchester University Press, 1993, p.88.

26. Jean Baudrillard, *Seduction*, trans. by Brian Singer, New York, St. Martin's Press, 1990, p.12.

participants are of indistinct and indeterminate identity. Although paid to perform what are often arduous and demanding tasks, these workers are ultimately players in a game which is played only with the signs of labour. Drawing a distinction between the female prostitute and the transvestite prostitute, Baudrillard claims that the prostitution of the transvestite is 'contiguous with the theatre, or with the make up, the ritual and burlesque ostentation of a sex whose own pleasure is absent'.[27] In a curious relay, as Sierra's remunerated participants perform the rituals of a labour whose purpose is absent, their burlesque identities as surrogate workers testify to their status as surrogate commodities. They perform at the level of human cosmetics.

XV

People paid to learn a phrase

CASA DE LA CULTURA DE ZINACANTÁN, MEXICO, MARCH 2001

Eleven Tzotzil Indian women are brought together in an auditorium to learn a phrase in Spanish, a language they do not speak. The phrase was the following:

'I am being paid to say something, the meaning of which I ignore.'
They receive two dollars each.

XVI

In a curious passage in volume one of *Capital,* Marx makes a comment which asserts the simultaneous feminine status of the objectified commodity and the rapacious masculinity of aggressive capitalist accumulation: 'Commodities are things, and therefore lack the power to resist man. If they are unwilling, he can use force; in other words, he can take possession of them'.[28] In a note following this remark, Marx makes reference to a passage in the *Dit du Lendit,* a satirical poem by the medieval French poet Guillot de Paris, where the poet enumerates the commodities to be found on offer at the fair of Lendit: 'alongside clothing, shoes, leather, implements of cultivation, skin etc. . . [were] . . . also *femmes folles de leur corps'.* In other words, for both poet and economist, the real commodities on display at the fair are the local prostitutes. The ultimate condition of the commodity, we are left to infer, is that of prostitution. As Sierra has remarked: 'If prostitution, a dominantly if not exclusively female labour, is a paradigm for work, it is also a paradigm for the much praised globalisation.'[29]

For Simmel, the act of remuneration itself implies a relationship of objectification and non-commitment, a relationship most clearly articulated in prostitution. He writes:

The relationship is more completely dissolved and more radically terminated by payment of money than by the gift of a specific object, which always, through its content, its choice and its use, retains an element of the person who has given it. Only money, which does not

27. *Ibid.,* p.14.

28. Karl Marx, *Op. cit.*, p.178.

29. Cited in Lars Bang Larsen, Art Now: *137 Artists at the Rise of the New Millennium,* ed. Uta Grosenick and Burkhard Riemschneider, Köln, Taschen, 2002, p.462.

imply any commitment, and which in principle is always at hand and welcomed, is the appropriate equivalent to the fleetingly intensified and just as fleetingly extinguished sexual appetite that is served by prostitution.[30]

With money as the basis of human exchange, capitalism-as-prostitution inevitably leads to a use of the human subject as 'means' and a breach of the moral imperative which grounds human relationships formulated by Kant:

> Kant's moral imperative never to use human beings as a mere means but to accept and treat them always, at the same time, as ends in themselves is blatantly disregarded *by both parties* in the case of prostitution. Of all human relationships, prostitution is perhaps the most striking instance of mutual degradation to a mere means, and this may be the strongest and most fundamental factor that places prostitution in such a close historical relationship to the money economy, the economy of 'means' in the strictest sense.[31]

This situation seems to be played out most disturbingly in Sierra's video work, *Ten people paid to masturbate.* That these men were mostly pimps and prostitutes is crucial. There is something about paying sex-workers to masturbate which fuses a prostitution-masturbation-axis of Sierra's intervention, a kind of short-circuiting the production paradigm. But the impact of Sierra's art lies not in individual works but in their cumulative effect. Again and again, either explicitly or implicitly, the socially useless unproductive labour in Sierra's remuneration actions most commonly invites parallels with masturbation or prostitution. In effect, the works exist along the fold of a masturbation/prostitution axis. The resultant relationship between viewer and performer in Sierra's remuneration actions is, in the end, one of 'mutual degradation'.

XVII

160cm line tattooed on four people
EL GALLO ARTE CONTEMPORÁNEO, SALAMANCA, SPAIN,
DECEMBER 2000

Four prostitutes addicted to heroin are hired for the price of a shot of heroin to give their consent to be tattooed. Normally they charge 2,000 or 3,000 pesetas, between fifteen and seventeen dollars, for fellatio, while the price of a shot of heroin is around 12,000 pesetas, around sixty-seven dollars.

XVIII

Sierra's remuneration actions position his workers as de-humanised objects, functioning on the level of commodities rather than as active human subjects. Whether this is a critical action against the dehumanisation of global capitalism, or a situation which merely reiterates and conserves the

30. Georg Simmel, *Op. cit.*, p.376.

31. *Ibid.*, p.377.

relations of capital, has to be renegotiated by each viewer for themselves. In the final analysis, Sierra may have more in common with the spectacular and objectifying concerns of Vanessa Beecroft—an artist from whom he seems at first distant—than with minimalist, Fluxus or activist artists. In her video, photographic work and live events with models, Beecroft also collapses the life-labour conditions of these women as she subjects them to the scopic regime of the fetishised, objectified, commodified body—a condition with which they are, no doubt, all too familiar. But she does so in a manner which confronts the viewer with the violence of their own act of looking. The violence of the gaze pertains whether we are watching supermodels or street workers, as we experience similar discomfort—perhaps Simmel's mutual degradation—when confronted by the spectacle of Santiago Sierra's remuneration actions.

XIX

Person saying a phrase
NEW STREET, BIRMINGHAM, FEBRUARY 2002

A homeless person is hired for £5 to say the following phrase:
'My participation in this project could generate profits of seventy-two thousand dollars. I was paid £5.'

XX

In a final note, the marginals of urban society—asylum seekers, the homeless, migrant workers, beggars, pimps and prostitutes—articulates Simmel's contention of money's congruence with those who are marginal. As Simmel concludes:

> Whereas money transaction becomes the *ultima ratio* of the socially disadvantaged and suppressed elements, the power of money contributes positively to the attainment of position, influence and enjoyments wherever people are excluded from achieving, by certain direct means, social rank and fulfilment as officials or in professions from which they are barred. Because money is indeed a mere means, though on an absolute, and since money lacks all particularity derived from whatever actual determinations, it is the unconditional *terminus a quo* to everything, as well as the unconditional *terminus ad quem* from everywhere.[32]

As the tactic of unproductive labour invites parallels with Keynes' proposal in 1936, the strategy of remuneration in Sierra's actions suggest his congruence with Simmel's theory of money as the *ultima ratio* of capitalist social relations. Interestingly enough, the money Sierra pays to his workers is normally paid in the local currency but its value is always converted into dollars, the currency of the international art world. It is as if he were articulating the dollar as the unconditional *terminus a quo* and *terminus ad quem* of both contemporary art and globalisation.

32. *Ibid.*, pp.222–223

Labour Exchange: A Dialogue between Ross Birrell and Santiago Sierra
MEXICO CITY—HELSINKI, AUGUST 2001

ROSS BIRRELL Why did you move to Mexico? Has this context changed your work in any way?

SANTIAGO SIERRA I had an idea of what I would find there. Mexico is an immense city that summarises the world's social conditions. There I realised that to talk about relations between classes of society, including labour relations, was to talk about hatred and its manifestations.

BIRRELL Do you see your work as political art? Perhaps as a kind of postmodern critical art?

SIERRA I would not be original answering that all art is political, but it is. The idea of being critical seduces me, nevertheless, we artists fabricate luxury products and we are distanced from the social praxis that would at least validate our commentaries. I do not know if this is a postmodern way of thinking, but I also believe that nothing, least of all art itself, can stop the suffering.

BIRRELL How important are the performance or performative aspects to your work. Are the performative aspects for you a critique of the commodification of art as in much early performance art?

SIERRA The fact that I use people in my work does not make me a performance artist. I treat them as objects in coherence to their availability in the market. On the other hand, I always try to include everything that happens around the piece as part of it. I do this, precisely with the intention of distancing my work from the theatrical and figurative aspects of performance art. I also do not dedicate my comments to art, only to its social implications.

BIRRELL You often remunerate participants in your work. Is this an ethical position? How do you decide how much to pay? How do you quantify the cost of their labour?

SIERRA The Nike from the characters in the Chapman brothers, or Serra's gigantic sculptures, or Koons' canvases were made by remunerated people, only that in many of my works that is the only theme. A remunerated person is the one who sells his or her body and time to the interests of a third person in a specific situation. This context defines the worker's fee and the intensity of his or her devotion. For me it is enough to pose this theme.

BIRRELL The jack-knifing of the truck on the highway is an audacious intervention into the traffic system, in the tradition of Situationist *détournement* of the public sphere. Has the SI strategy of *détournement* of the *Society of the Spectacle* informed the context of making your work?

SIERRA I am not an optimist. The type of works such as the burned art gallery or the barricade in Ireland are beautiful but their inclusion in my book as works of art demonstrates their insufficiency as generators of any kind of transformation.

BIRRELL The scopic regime to which Vanessa Beecroft, for example, subjects her models (commodified female bodies) and objectifies them before the camera (and voyeuristic audience) seems to be challenged in the P.S.1 installation, *A person paid for three hundred and sixty continuous working hours*—where you built a wall across the gallery space behind which

someone lived for the duration of the exhibition, fed by gallery attendants through a small gap in the wall. Here, the invisibility rather than visibility of the man employed to live behind the wall seemed to be at stake. Are you suggesting a regime of invisibility which surrounds difference and otherness?

SIERRA Yes, the objectification is the key. In P.S.1 the wall divided the gallery into two parts. On one side there were people enjoying their leisure time, recharging their energies before going back to work while on the other side a person was working by simply giving up his time. Both sides of the wall made up the piece, both sides were composed of objects for hire.

BIRRELL In the recent video work *Persons paid to have their hair dyed blonde* (Venice Biennale, 2001) you seem to articulate the simultaneous eradication and commodification of difference in global markets. An important part of this work, which had a very informal performative mode, seemed to be the various conversations and dialogues which resulted between the participants. How important is dialogue in your work? Do you consider dialogue as a means of celebrating difference?

SIERRA The only difference I consider is the social one and the only intersocial dialogue is confrontation.

Truth and Beauty in the Digital Age

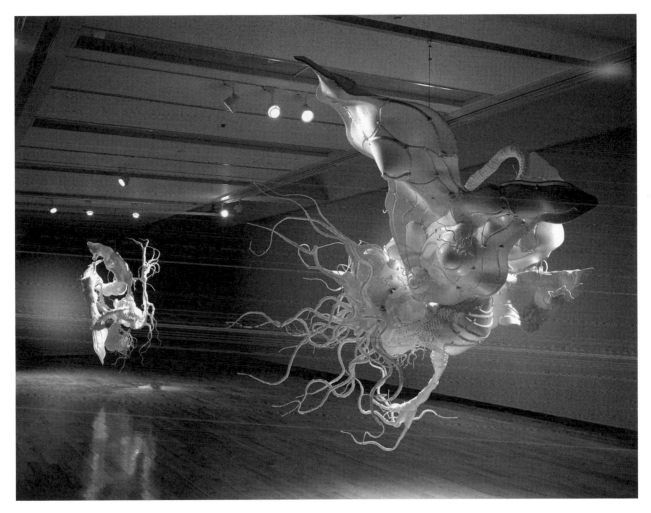

Supernova (foreground) and Chrysalis (background), 2000
Installation view, Fukuoka Asian Art Museum, 2000
Photo: Shinomiya Yuji

Lee Bul

LEE BUL

Artist

Born 1964, Yongwol, South Korea

Lives and works in Seoul, South Korea

Stylistically and thematically diverse, Lee Bul's aesthetic strategies span from traditional media such as sculpture and installation to performance and video. The relationship between women and technology, as for instance articulated in ideas about woman as machine or in the sexualisation and feminisation of technology, plays an important role in her complex work since the mid-1980s as evident in the series of *Cyborgs*. These seemingly perfect objects made from smooth white silicon reveal themselves as armour-clad, fragmented and heavily sexualised female-like figures. They epitomise the Korean artist's radical stance vis-à-vis the highly gendered subtext of new technology and media developments. Lee Bul's longing for purity and beauty is tangibly evident in almost all her work. Their illusory and ephemeral nature as well as their ambivalent gendered inscriptions become breathtakingly present in her installations with fresh fish, her contribution to the Venice Biennale in 1997 for example: over time, the fish—arranged and beautifully embellished with fashion jewellery—starts rotting and disintegrating and releases an unbearable stench. The smell of death brings truth before beauty. Her enquiries into the complex and conflicting facets of femininity and womanhood in the age of bioengineering and virtual reality draw on Asian culture past and present, on the phenomena of global capitalism and, likewise, on the facts and the fiction of technological progress. Her original in(ter)vention re-evaluates precedents of Western Modernism and Asian art history and also refers to popular cultural material. Often her objects, installations or performances touch on the familiar, fashionable and mundane like computer and video games or Karaoke, and intervene into everyday situations in an imaginative and provocative manner. As *Hydra* for instance, the artist has publicly performed the monstrous, yet beautiful phantasmagorical female to directly address collective (male) imaginations, desires and anxieties. In some of her installations such as *Gravity Greater than Velocity* (1999) the audience is invited to participate actively in order to appropriate and re-experience, individually, existing technologies and common narratives.

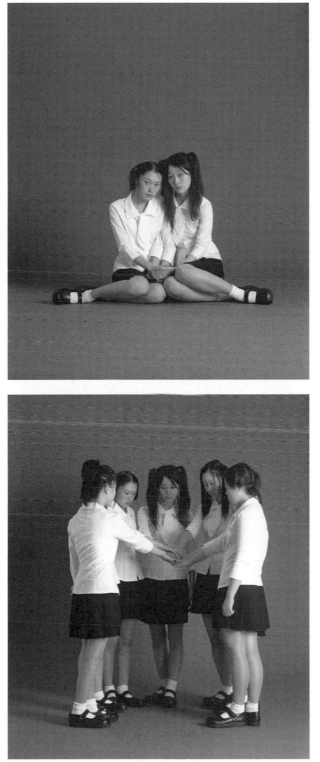

Amateurs
Two production stills, 1999

Amateurs
Six production
stills, 1999

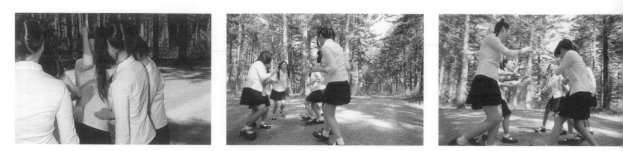

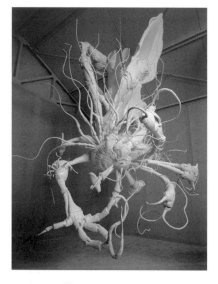

Amaryllis
Hand-cut polyurethane panels on
aluminium armature, enamel
coating, 210 x 120 x 180cm,
1999

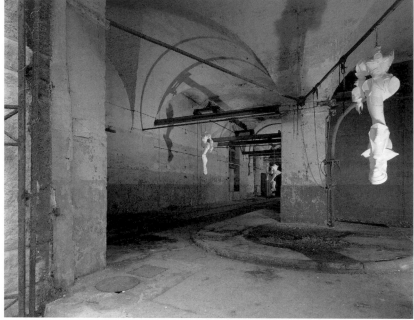

Cyborg w3 (foreground) and Cyborg w2 (background), 1998
Installation view, Venice Biennale, 1999

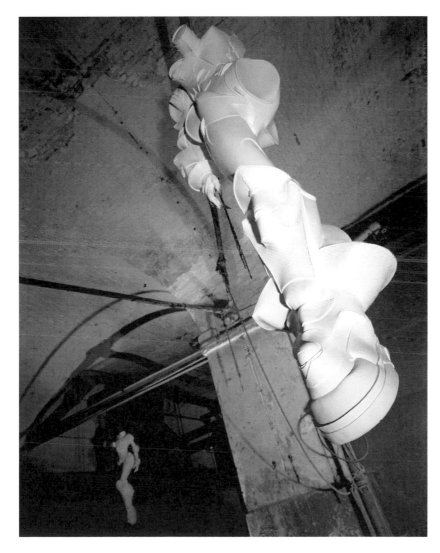

Cyborg w4, 1998
Installation view,
Venice Biennale, 1999

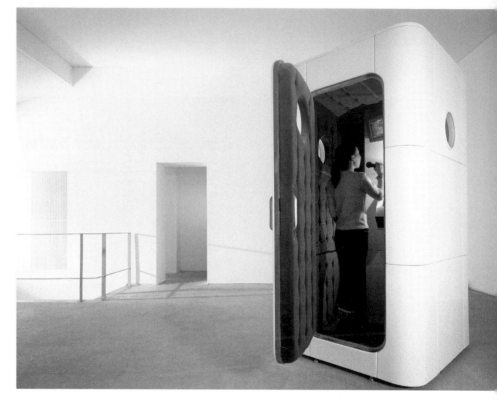

Gravity Greater than Velocity II
(Reconstruction of the 1999 original)
Polycarbonate panels on stainless steel
frame, velvet, electronic equipment,
214 x 124 x 184cm, 2000

Anthem
Three production stills, 2000

Between East and West

Pencils

Yasuko Toyoshima
in conversation with
Beverley Hood

YASUKO TOYOSHIMA
Artist
Born 1967 in Saitama, Japan
Lives and works in Tokyo, Japan

BEVERLEY HOOD
Artist, Postgraduate Co-ordinator
School of Visual Communications,
Edinburgh College of Art, Scotland, UK
Born 1970 in Darlington, England, UK
Lives and works in Edinburgh

BEVERLEY HOOD · MON, 27 AUG 2001, 11:28:24 +0100 · I saw your solo exhibition at CAS, Osaka. Can you tell me about the work you exhibited, and how the show came about?

TOYOSHIMA YASUKO · MON, 27 AUG 2001, 21:21:36 +0900 · The show I presented at CAS consisted of seven series of works. In order to emphasise that they are sequential projects, I displayed them progressively around the space.

The works are: *Mini-Investment, Open Bank Account, Pencil/Ruler, Fishing Float, Transfer To My Bank Account, Calligraphy,* and *Report Card.* These titles are simply the terms used in daily life. For example, *Mini-Investment* consists of real share certificates, which I bought, and *Calligraphy* is my calligraphy corrected by my writing master.

My works consist of real statements, transactions, situations and objects that have occurred in my everyday life. They reflect myself as I am shaped by society. It means that I am my work.

I had the show at CAS because a young curator recommended me. CAS is a non-profit space for experimental contemporary art, especially works that are difficult to show commercially. When I heard of the concept of CAS, I was curious to know how they manage to be independent. As soon as I was asked, I decided to show there.

HOOD · TUE, 28 AUG 2001, 18:18:50 +0100 · I was drawn to your work because of its subversive nature.

TOYOSHIMA · WED, 29 AUG 2001, 12:50:18 +0900 · I see my work as paradoxically subversive. In my work, there is not a concrete character or object understood by my conscience.

This is an important aspect. The way I am grappling with my own identification has become my method. A major premise of my work is my identification. It is the only thing I can approach every day. All of the material I described previously is a metaphor of myself. This way, I am able to shift many daily necessities and systems to suit myself and my way of thinking.

HOOD · WED, 29 AUG 2002, 17:51:37 +0100 · Can you explain your statement that 'there is not a concrete character or object understood by my conscience'?

TOYOSHIMA · THU, 30 AUG 2001, 22:48:09 +0900 · I would like to say that my works don't have a *conscience* coming out of a so-called 'politically correct' issue.

Although I am quoting the stock market, the bank and education systems, I am not particularly interested in them. My thread of thinking is to increase the categories related directly to me as much as I can, so that the work does not only approach a reality of the world, but also looks at institutionalisation.

Quoting the world's background has of course become an artist's framework, I think. My ideal approach is to disturb the audience but not

in an offensive way. I believe that introspection is the only way for an artist. Implicating myself is the way I prefer . . . as a means of expression.

My *Self* is an accurate frame. It has become a hypothetical fulcrum. And, of course, I have visual and other real material about myself. Ordinarily, they are my private property, but they are able to shift to become my ideal *Works*.

HOOD · WED, 29 AUG 2001, 17:51:45 +0100 · Having spent an intensive few weeks in Japan before seeing your work I understood this supervision on one level as a response to the order and efficiency of Japan. Can you discuss this a bit. Also, do you regard your work's subversion as applicable cross-culturally?

TOYOSHIMA · THU, 06 SEP 2001, 17:04:05 +0900 · Your word *subversion* reminds me of the word *blank*.

In 1989, I did a kind of drawing work titled *Fill in the Blank*. The frame was an answer sheet for a school test. I used it by not filling in the blank area marked to write in the answer. I only filled out the margins, that is, all the remaining empty spaces. The blank in which the answer should have been written, changed to become the left-over empty space.

The *subversion* you see as inherent in my aesthetic strategy is part of *Blank*. *Blank* is empty space, having nothing in it . . . it functions like a Black Box or black hole. It is like the X for mathematical functions. It is impossible to define X or subversion universally, but if there was a hypothetical thread—I call it a frame—we could put in an appropriate numeral as a substitute.

I try to catch the *blank* in all spaces, carefully, and across and beyond cultural differences. The reason I say 'carefully' is, to tell the truth, I doubt that crossing cultures would be possible because of the hegemony of power. I would like to ask you if the *blank* I meant (subversion is partly contained in this term), is applicable across cultures, beyond the hegemonial relations of power and values within which it has been constructed?

HOOD · THU, 6 SEP 2001, 17:49:30 +0100 · Can you expand on the restrictions of hegemony you have mentioned?

TOYOSHIMA · SAT, 08 SEP 2001, 15:46:17 +0900 · I mentioned cultural hegemony and hierarchy. Although we are totally free to see art, we know there are many complicated historical threads, requirements and conditions.

Looking at contemporary art requires an audience to use shared criteria, which have been constructed based on modern European ideology. Japanese artists have been participating in western contemporary art only after these criteria had emerged and had gained international hegemonial power.

The concept of contemporary art is said to have been imported into Japan. I am now in the middle of investigating this issue. In my case . . . I naturally sympathise with conceptual art, which mostly appeared in the 1960s and 70s. These artists used ordinary materials instead of painting. It reminds me of some kind of local people who experience almost the same sort of split. They have been living as neighbours, are old-fashioned—labelled eccentric or odd—because they believe in their own values and criteria. They have searched for the real meaning of (their) life.

Ruler

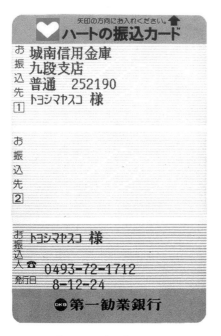

*Transfer to my bank account,
from Daiichikangin to Johnan*

They appear almost similar to staunch religious believers. If one transfers that to the aesthetic sphere, they could say they are artists. Before Japan became conscious of individualism, these kinds of people were of course already in existence.

My attitude to art is connected to those people. If I had not been aware of contemporary art, I might be living as such a gloomy odd neighbour. And, in this case, I might try to represent my ideas about 'who am I' in some way. My situation now is no different. I would not be confused if there was no art.

It is said—and perhaps it is common sense—that contemporary art is the practice for a world that has finished with art. I love this kind of paradoxical idea. It is thrilling, realistic. It is similar to the system of our society.

I hope that people from other countries sympathise with my work and share my ideology and concepts. Yet, I am concerned about such a simple desire too. If another artist were to force such a desire upon me, if I were in the role of the viewer of their work, my position would be inferior. If I were totally sympathetic, I would doubt myself, thinking that I might be controlled by some kind of art hierarchy.

According to such an attitude, misunderstanding is a positive, liberating reaction. It could be said to expand the interpretation of art. I wish to share my works across a diversity of cultures, but on the other hand I realise that the reach and understanding of contemporary art is limited to the people who share the same social and cultural system. Trying to unify the threads of art produces many victims.

The above is a cliché.

HOOD · WED, 12 SEP 2001, 23:38:02 +0100 · To answer your question to me about hegemony . . .

I agree that there are times when knowledge of cultural history is required to understand an art work. With your work I feel there are fundamental concerns relating to the contemporary human condition, which runs across cultural differences. It is interesting to me that my perception of your work at times is perhaps shifted due to my own cultural background and a misunderstanding of its specifics. However, I have been able to relate to your work's tone at a deeper level of intuition and understanding.

In saying this, when I visited CAS I was guided around the exhibition by a member of staff there. Because of the language barrier, I would not have been able to understand much of your work, e.g. *Report Card* and *Mini-Investment*. The works that function without specific language requirements (such as *Pencil/Ruler*) engaged me so strongly that I was compelled to spend time deciphering and scrutinising the text-based works, which were initially inaccessible to me.

HOOD · THU, 30 AUGUST 2001, 10:27:34 +0100 · Do you see your work as essentially Japanese or representing and investigating what it is to be Japanese?

TOYOSHIMA · THU, 06 SEPTEMBER 2001, 22:54:41 +0900 · I see my work as all of the above, although I need to investigate Japanese-ness much further.

The fact that I am Japanese is also one of the frames for my work. I try

to understand the localisation of people. It gives us reality. It is a way to see clearly our space and time.

HOOD · SUN, 02 SEP 2001, 21:13:33 +0100 · You create work in response to ordinary or everyday life situations. These situations undergo a process of transformation in your work, revealing subtle discrepancies.

TOYOSHIMA · FRI, 07 SEP 2001, 01:53:16 +0900 · The key word is *I*. Needless to say, *I* is grammatically the first person singular. Everyone speaks about themselves: *I am* . . .

 I means the one and only centre, which is a place in the exact middle of a part or a point in our society. According to this concept, we are able to recognise subtly uncountable *Centre Points* in the world. There are conceptually numerous *Centre Points* within space. It means there are numerous frames for my work.

 The transformation of art works from ordinary life occurs through the usage of *I*, through shifting *I*. This *I* becomes a code in my working process.

HOOD · TUE, 04 SEP 2001, 20:52:10 +0100 · We have already mentioned that your art and ideas are deeply related to Japanese culture and everyday life. How has working in Europe influenced your work?

TOYOSHIMA · MON, 10 SEP 2001, 13:21:45 +0900 · To carefully use the same system or similar systems as codes is my way of working in other countries; I am just shifting my method to another place. There are some works, however, which are impossible to shift. I think positively about that because there must be some aspects to local culture, which cannot be shifted to another culture. I can characterise them as difficulties. They can give us a feeling of sympathy and respect for another locality, when our own culture does not operate the same system.

 My work in Guernsey in 1998 was a video installation titled *Origination*. I shot videos of students writing their test sheet at their local college. I also filmed myself as I noted down the answers for a local mathematics workbook, which I borrowed from the mathematics teacher. In the video only the writing hand holding and guiding the pencil and the test answer sheet are visible. At the beginning of the residency, I was concentrating on carrying out the test performance on my own. A few days later, the curator recommended that I invite the Art and Design students from the local college to participate in my project. This way I could develop my concept. I realised that through asking potential spectators to participate I could expand upon self-regulation as a theme, as the frame for the work. I could shift *I* to the students.

 I think the audience was able to follow what happened on screen. The writing hand obviously suggested a thinking process within a limited time frame (testing). And it shows the very moment when the answer originates or appears… as the blanks were (gradually filled) in. Yet, the documented outcome on video appears more abstract, the hands' movements look like dancing.

 This year, I participated in a project called Artist Initiative Links *Puddles 2001*.

 It was an artist-run project with a show in Germany (Dortmund and Muenster). CAS recommended me for the exhibition. My works, titled *Button Hole* and *Curtain*, were based on some sort of daily necessities,

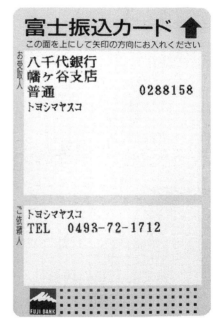

Transfer to my bank account, from Fuji to Yashiyo

which I observed there but also in Japan. In *Curtain*, I simply sewed fabric on to the ready-made curtain to make an original wave. The audience could change the parameter of the wave I sewed.

The space where I showed the work contains far more than an art space. The building accommodates many organisations. The curtain looked like a permanent feature, part of the soft furnishing. I was emphasising this aspect, pretending that the curtain was an integral part of the space's interior design. I did not put up notices like 'Please do not touch', and thus, people passing tended to touch the work because it did not particularly look like an art work.

In *Button Hole* I asked members of an artists' organisation to lend me their shirts and made button holes on the front of the shirt. I placed them on the button carrying side, between the regular buttons, e.g. on the opposite site of where they functionally need to appear. These button holes remained invisible when the shirt was worn the usual way. Only when its owner put it on or took it off did my intervention become obvious to them. Obviously, the lenders of the shirts were aware of my action. After the show I returned the shirts and asked their owners to wear them some-times as part of their routine. This meant that my work would stand a chance of presentation in everyday life, outside of an exhibition format.

HOOD · THU, 06 SEP, 16:49:55 +0100 · Yasuko, you use identification in your work, in particular your own identification as an individual. The individual is more typically emphasised in western culture and the collective associated with Japan. Do you see the emphasis on individual and group changing in Japan?

TOYOSHIMA · TUE 11 SEP 2001, 03:04:16 +0900 · Although the Japanese mentality has not changed, government policy is attempting changes towards an increased individualism because of recession. There has been a shift in responsibilities towards the individual due to the failure of the government to continue to provide for all. And we know that the government's failure was the electorate's failure.

The individual is shaped by the group and the group is shaped by the individual. I enjoy this stereotypical tautology because of its similar construction to the frames of my work.

I see the emphasis on the individual changing in Japan as another way of defining a group. As you say, I concentrate on the identification of the individual. It is the same as trying to visualise the group.

HOOD · MON, 10 SEP 2001, 23:33:42 +0100 · You said that the situation of working with the CAS Gallery in Osaka was unusual in Japan, CAS not being commercial. This suggests interesting differences with Scotland where we have a very strong artist-run gallery, group and organisational background. I found very little of alternative gallery structures in Japan, such as CAS and commandN in Tokyo.

TOYOSHIMA · TUE, 11 SEP 2001, 16:51:47 +0900 · That aspect you saw in Japan is true. As you observed, there are very few alternative activities in Japan. Although I am not a member of CAS, I have been linked to them for the past two years. I am happy about this opportunity. Currently, I am considering my own strategy outwith anyone else's organisation.

I think during your stay in Japan you saw that some young Japanese

galleries are trying to create a market for contemporary art. At the same time, the museum's art projects are being affected in extent and number by budget cuts due to the economic recession. The rental gallery system, which was the ordinary system in Japan, has become questioned by artists wondering 'is this good for artists or not?'

This reminds me that I should hurry up making my own independent space. I suppose a number of artists are beginning to think like me. My own work is not seen by people as 'merchandise'. I could not and should not rely on commercial galleries because I cannot take on the responsibility for the reception of my work by an audience at the present time. And I do not think that there is a strategy against today's Japanese art market (although it is also said that there is no market). I am trying to begin to think about what could become art merchandise. It does not have to mean following the current system. It means to take on responsibility for my position in this society. However, this is very different.

HOOD · WED, 12 SEP 2001, 23:38:02 +0100 · How does CAS manage to be independent? Are they funded by the government, privately, through membership schemes?

TOYOSHIMA · FRI, 14 SEP 2001, 02:43:48 +0900 · This year, they will begin to get a budget from the government. Japan has just started a new system called NPO. Until then (and still at present), they continue to be funded by artists and art enthusiasts.

HOOD · TUE, 11 SEP 2001, 22:23:30 +0100 · What projects and exhibitions are you working on at the moment and planning for the future?

TOYOSHIMA · FRI, 14 SEP 2001, 02:43:48 +0900 · I am working on a project called *Blind Date*, which is organised by a Danish artist. Danish and Japanese artists are taking part in one-to-one dialogues for the project. It is almost the same as this discussion with you, and takes place initially as an Internet communication.

Also, there is a magazine project curated by an Australian artist, entitled *Gloss*. I am making work for the magazine.

In February 2002 I might visit and show work in an art space in Novi Sad, Serbia.

Transfer to my bank account, from Yashiyo to Tokyomitsubishi

cary peppermint
pop_accounts@restlessculture.net

postsex@restlessculture.net

high@restlessculture.net

o_america@restlessculture.net

From: MelisFr@aol.com
To: o_america@restlessculture.net
Date: Saturday, July 15, 2000 6:52 PM
Subject: Greetings from the California Girl

What's up? Sorry I haven't called in a while, but I need to get one of those stupid phone cards and I just haven't done it yet...I am a California girl now! I still haven't found a place to live, but I am currently staying with Laurie: (619) 243-6291 is our phone number. You can call whenever you want, I sometimes go apartment hunting or to the beach, but I mostly sit here and wait for something to happen. Hoss also made it to Ca, and is doing well, just moved into a 2bd house with a fenced in yard for Porkchop (the dog)...I don't know if you heard about the most recent family drama at Mike Norton's lake house, but he and Jess apparently got into a fight, and Mike N gave Jess a shiner! The next day Jess called my brother and asked him if he killed himself would he take care of his dog...Hoss just said sure, because we see no reason to try to talk him out of it anymore. Anyway, I am completely relieved to be as far away from the family as possible at this time. You will have to let me know if there's any drama during your visit! Write me back at this address sometime and let me know what's going on in your world...I miss you!!!!

Love, Melissa

upsidedownclown@restlessculture.net

memory@restlessculture.net

bearchair@restlessculture.net

exposure@restlessculture.net

From: PhotoWoody@aol.com
To: memory@restlessculture.net
Date: Monday, February 21, 2000 10:51 AM
Subject: Re: In Memory Page

Hi there,

Thanks for the nice words about my page!
I get a lot on mail on that page from
people who don't even know anyone on
there, that say how they were touched by
it, and that makes me feel good &
sad at the same time. I had to call Peggy
mom (1 St. girl on that page) to get the
rights dates, she said it was nice to know
after 20 years that Peggy was still
thought of, I had a guy out west say that
that page inspired the paint job on his
new Harley (lost bro's & sisters) Sonny
would like that, I miss him a lot, he was
the high light of dinner at Deano's !!!!! its
just not the same place without him.
Keep in touch.

WOODY
http://www.shadows-shapes.com/

unknowndriver@restlessculture.net

contactus@restlessculture.net

CARY PEPPERMINT
Artist
Born 1970 in USA
Lives and works in
New York, USA

A Public Auction of Private Art Works

Auction at Kimbolton Castle Clive Stewart-Lockhart, the auctioneer, taking bids during the sale in the courtyard, 2001

Nina Pope
introduced by
Simon Yuill

NINA POPE

Artist

Born 1968 in East Anglia, England, UK

Lives and works in England

Photographs © Nina Pope, 2001

Running through much of Nina Pope's work, and in particular her collaborations with Karen Guthrie, is the re-use of existing structures, almost as 'found objects', from which a project is developed. This is evident in works such as *A Hypertext Journal* and */Broadcast/* amongst others. In both these works a classic text, Boswell's *A Journal of a Tour to the Hebrides* in the first case, and Chaucer's *Canterbury Tales* in the latter, was used as the framework for a project which explored new distinctive forms of narrative and authorship opened up by the emergent technologies of the Internet and online video broadcast.

The adoption of an existing structure enables artistic practice to insert itself within other 'operation systems' without necessarily mimicking or reproducing them. Frequently, the use of one pre-given system enables the adoption of a critical stance, or position of enquiry, towards another system, or context, which a more direct artistic engagement might preclude or diminish. In *A Public Auction of Private Art Works* the structures of a house auction—the catalogue, the sales viewing, and the evaluation and bidding of items in the sale—became a means of exploring quite diverse but revealingly intertwined avenues of personal history, local identity and commercial value. These issues are complicated by the layered identities of the work's location in Kimbolton Castle, which was once the stately home of the Dukes of Manchester and is now a private school. The text here is based on an interview with Nina Pope conducted on the day after the auction.

NINA POPE I have worked with this idea before, particularly in my collaboration with Karen Guthrie starting with *A HyperText Journal,* the piece we developed when we followed the journey Boswell and Johnson made to the Western Isles in Scotland. That gave us an interest in revisiting not necessarily just a text but something that had been either a turning point or very important at a particular time, and trying to re-appraise it in a contemporary context through using technology as a vehicle for re-examination. We did the same with */Broadcast/,* the project that was the annual event for the Tate Gallery in 1999, where we took, very loosely, the idea of Chaucer's *Canterbury Tales* and worked with twenty-nine contemporary pilgrims who went on journeys of their own choosing but all to different locations. We used the technology of web-casting through which they could tell a coherent body of stories all on the one day. Again, we employed the collection of stories as a vehicle, but, via technology, delivered the stories in a very different way. *A Public Auction of Private Art Works* was the third piece where an existing document was taken as a starting point for a contemporary project through which it has been reworked within someone else's system: the school system and the auction system. This ties in with other work I have done. In *Safe Bet*, for example, I worked with Ladbrokes, the bookmakers, and plugged into their system similarly to how I worked with the auctioneers.

Sometimes I use a structure that could be easily criticised in order to scrutinise another system. In the Ladbrokes piece, I was looking at the whole idea of art prizes and the problems around them, I used Ladbrokes' system of bookmaking as a means of doing this, but I was not really passing judgement on betting as such. In a way, my entirely neutral stance towards the system of betting was important in highlighting the work's criticism of the art prize system.

In using somebody else's system I am trying to make people re-assess how they are approaching an art object and the value of that, or in making them think more about the way art works are made and the values involved there. This was brought out in *Safe Bet*, where I followed the process of all the artists making their pieces very closely and then compared that to something as quick and facile as a horse race.

A Public Auction of Private Art has developed over nearly two years from initial discussions to the final resolution with the sale taking place yesterday, in Kimbolton Castle, Cambridgeshire, the former home of the Dukes of Manchester. It is renowned as the place where Catherine of Aragon was locked up, when Henry VIII got rid of her. She is supposed to haunt the castle. Now, the building houses a school (which used to exist in the grounds outside the castle), where I was once a pupil. The school was four hundred years old last year. The project was kicked off when the school approached me and asked if I would like to make a piece of work to celebrate their anniversary.

At first, I had been a pupil there myself. When I came to do the final project I wanted to downplay this, but it was obviously absolutely critical to me, making the decision to go through with it, and it obviously meant that there were levels of complexity to it for me that would not have been in place otherwise. I was quite nervous about telling the artists that I had been there before. It is quite exposing to invite a thousand people to come and see where you spent your formative years. The feedback I got from the artists, however, was that they felt this made it more interesting for them, imagining what it would have been like for me, thinking of their own school and art experience, or thinking about the place you were when you decided that you perhaps wanted to make art or what it would be like to be an artist, on that very basic kind of level. I had never visited an art gallery until I was in my final year at that school, so for me it is all tied in with that, I suppose. But at first I did not like the idea of making a piece of work for my old school and I was thinking I would just say 'no'. In the course of a discussion with the art teacher, Frank Priest, however, I learned about the auction which had taken place there in 1949. He had a list of the paintings which were sold in the original auction. As soon as I saw that I had the idea of staging another auction and using the document of the original auction catalogue as the inspiration for the new piece of work.

I researched all the details of the original sale. It was an amazing event that took place over four days. Every single thing in the house was flogged, from Reynolds' paintings, a four poster-bed and an old woman's carriage, right through to knick-knacks from the dungeon and kitchen including the serviettes, the cutlery, the mangles, the washing equipment and things like that. The catalogue is like a journey through all of these

The Catalogue for the Auction at Kimbolton Castle in 1949

Lot 51, Tim Olden,
949–78 rpm record player, 2001

Lot 51, Tim Olden,
1949–78 rpm record, 2001

objects and the lives of the people who lived there.

I spent a long time trying to trace the buyers of the original items, because I was quite interested in reconstructing what had happened to the auctioned objects as well as to their new owners. Yet it turned out to be extremely difficult to recover all this information. Although 1949 was not that long ago—it still lies within living memory—you would think a few of those items would still be floating around, or the people who had bought them, but it seems that the objects changed hands and disappeared unbelievably quickly. I talked to two people who had been at the original auction, both of whom were really interesting, but I still did not get a clear picture of what the event was like. That was still left very much to my imagination, which was good as the list in itself is so evocative. The original catalogue was illustrated but there were only ten pictures, so you have this glimpse of what the original objects might have been like but as it is not a comprehensive colour catalogue of pictures you are left to imagine what a lot of things would be.

The new catalogue is a key element to the whole project. The auction itself is also important but I felt that getting the tone of the catalogue right was critical. I wanted you to know the minute you picked it up that it was an auction catalogue but I wanted it, also, to look like it was not an auction catalogue. Therefore I tried to achieve a balance between the documentation mimicking a contemporary art catalogue, but also looking like something that told you it was about a bigger, broader project. From the entries to the layout and the quality of the images, everything was carefully considered. I also commissioned a printing firm that usually produces catalogues for Christie's and Sotheby's.

For the restaged auction I focused on commissioning a group of contemporary artists and designers to make new objects based on items from the original list. Frank Priest continued to research the original painting collection and we borrowed back from other museums some of those works. Together with other artists, such as Anna Best and Rosalind Kunath, I also run workshops with the pupils of the school. The pupils produced their own works and these were included in the auction alongside those of the invited artists.

The viewing week was marked by a display that came close to both an exhibition as a well as an auction viewing. It brought together the previously auctioned work and the new objects. The viewing week took place in the state rooms of the castle. The event finished with a sale that took ninety minutes.

I worked with the way an auction would ordinarily operate. The auctioneers lot up objects to try and get a flow through the order of sale. Therefore they select very carefully what they pick to auction first and what is left to the end. In discussion with Clive Stewart-Lockhart, the appointed auctioneer, I developed an order of lots. Yet this selection was not reflected in the viewing display. The lot numbers were dotted around and one had to flick through the catalogue to make those links. In the new catalogue each contributor has got a new lot number included as well as their name and the title of the work. Further down in the individual entries the original lot number that the invited artists chose to respond to through their object was listed.

Lot 12, Anna Best
Steep Mountains, 2001

House sale catalogues do not contain any biographical details unless the items were made by a very famous artist. Even a contemporary art auction catalogue says very little about the individual work and its creator. However, I felt that the publication for this specific auction would benefit from additional details. I knew that the audience, in the main, would not be familiar with the participating artists. And because of the nature of contemporary art they may have had difficulties in understanding the work unless some information were provided in the catalogue

Choosing the auctioneer required careful consideration too. The original sale was conducted by Knight, Frank and Rutley, which still exists, but which no longer deals with house sales. After engaging in a whole series of negotiations with different auctioneers I eventually linked up with Dreweatt Neate, who are one of the bigger auction houses, yet are not London-based. I spent some time talking about the project with Clive Stewart-Lockhart, and felt that he understood why and how I wanted to use their system. It became clear to me through our discussion that he was willing to invest in the project as a collaboration. I later discovered that he featured on the *Antiques Roadshow* and that he was a bit of a showman, so that was an added bonus. This was very similar to the *Festival of Lying* where we used a local estate agent to compère the event. He and Clive were very alike, in that you could trust your sense that this person had the right kind of character to set the tone of the project.

Clive ran the sale exactly as he would hold a standard house auction. There was nothing extraordinary about the way it was conducted, except that a lot of the objects were not what he would ordinarily be selling. This added a slightly surreal twist to the event.

On the day itself the auctioneers arrived as a team and set up office in the building. They brought with them all the commission bids, which means the bids left with them either by phone, fax or by email prior to the sale. Everyone who attended the auction on the day in order to bid was asked to register and given a number. During the day the auction firm held an open office. The auction took place in the courtyard that opened out from the viewing rooms with Clive standing on the steps leading down to the yard, with the audience fanned around him. As each lot came up someone would bring it out above the auctioneer at the top of the steps. As soon as it was sold, the bidder was able to pay and the object was packed and handed over. It is a very wham bam and then it is over kind of thing.

Lot 55, Elizabeth Wright
Kimbolton City Comprehensive School,
2001

We had a fantastic team of stewards who were people from the village. There were seventy of them and each did hour-long shifts in the show, which were organised by a woman who works for the local history society. One volunteer was particularly good. She came every day because she got so into talking to people about the work and seeing them respond to that. Stories would develop out of the narratives that she had developed with the objects. In a gallery I would not normally want somebody coming up to me and talking to me about the work. People who came to see the show, however, responded warmly to somebody chatting to them about it and going through the catalogue with them. Eventually, I started encouraging all the stewards to do this as it really did seem to make people's visit. Most people who came would spend an hour there and some would spend two hours and then come back again. Obviously, this was very different to the whip round the gallery that I would ordinarily do and it was heartening to see that kind of dynamic developing.

Before all this, the pricing of the objects was negotiated between the artists and myself. Clive and I had talked about the advice that he would give to them. He drafted a letter, which I sent to the artists, explaining the auction process and the valuation. For example, work auctioned does not normally reach as high a price as it would if it were sold through a gallery. Yet, I think I am right in saying that the artist would actually get back a higher percentage of the revenue. In retrospect, some participants might have set their reserve prices slightly on the low side because, I think, almost all of them wanted their work to sell. They felt the actual sale was so integral to the project that they did not want to be left with the object at the end. For that reason I did not determine a reserve for my object at all. Some artists played with the value of the object, Anna Best for instance. Her piece, called *Steep Mountain,* was based on the link, whether it was real or not, between her family name Montague, and the Montagues who had lived in the castle. Montague translates to 'steep mountain'. The artist connected the making of the object with an extensive enquiry into family history. She collated loads and loads of archive family photographs from the recent past and photographed them arranged on her computer screen. In the show we exhibited a few slides of this piece, but what she actually auctioned was her role of undeveloped film. The acquired object could either be worth the price of an undeveloped role of film, or however much the photographs printed from it would be if they were sold.

Another piece that operated most effectively with the concept of value was a record. The original list contained a gramophone that Tim Olden chose as his lot. He produced a record using only samples from 1949, which he cut up into a very contemporary sounding piece of music. The compilation of sound bites from those samples produced a rather contemporary piece of music. One side of the disk was recorded at 45 rpm, the other at 78 rpm. The record was produced as a single pressing on to an acetate dub plate. DJs normally use this type of pressing, which only lasts about thirty plays. During the viewing and the auction we played a CD recording of similar samples but not the actual piece. Tim wanted to play with the idea that the buyer could be, potentially, the only person to ever hear this record. If they chose to play it, it would immediately

Lot 56, Nina Pope
A Public Auction of Private Art Works,
2001

start to degrade.

A couple of people wanted to make a work, which made a general statement about the entire situation rather than engaging in a response to an original lot number. Elizabeth Wright developed a piece called *Kimbolton City Comprehensive* which was an architect's paper model, mixing 1960s modular architecture with the architecture of the castle. The castle is rather more like a fortified house than a castle. The artist fused elements from its historical architecture with elements of the comprehensive school's modern structure. This corresponded to a modified aerial view of the village, from which the castle was removed, as well as to an architect's plan of the model. The model sat right in the middle of the room where you first entered the show. This set a tone of enquiry for the project which worked on a variety of levels. Everybody got something out of that work, from the pupils of the school, through to the people who lived in the village, and those who came to see the exhibition.

My lot consisted of a documentation of the overall project. The person who bought it intended to give it to the County Records Office, where the original catalogue is archived too.

The following individuals were commissioned to contribute to the project (in order of their lot number):
Ben Coode-Adams, Howard Sooley, Rosalind Kunath, Victoria Cox, Michael MurWn, Patrick McBride, Rachel Mimiec, Anna Best, Victoria Clare Bernie, Sophie English, Margarita Gluzberg, Edward Harper, Elizabeth Hobbs, Lorrice Douglas, Marcus Coates, Peter Foster, Mark Bennett, Adam Sutherland, Zoe Walker, Richard Slee, John Hunter, Louise K. Wilson, Nina Saunders, Claire Shoosmith, Terry Sladden, Lucy Wells, Isabelle Priest, Freddie Robins, Rosie Gibson, Clare Burrows, Jenny Brownrigg, Tim Olden, Rob Kesseler, Rob Godman, Soraya Smithson, Elizabeth Wright.

Selected Bibliography

General Reading

AVILLEZ, M. (1996),
Being Online: Net Subjectivity,
New York, Lusitania Press

BELL, D. (2001),
An Introduction to Cybercultures,
London and New York, Routledge

BELL, D., KENNEDY, B.M. (2000),
The Cybercultures Reader,
London and New York, Routledge

CALCUTT, A. (1999),
*White Noise: An A-Z of the Contradictions
of Cyberculture,* London, Macmillan

CASSELL, J., JENKINS, H. (1998),
*From Barbie to Mortal Combat:
Gender and Computer Games,*
Cambridge, Mass., The MIT Press

CRITICAL ART ENSEMBLE (1996),
*Electronic Civil Disobedience and Other
Unpopular Ideas,*
New York, Automedia

CRITICAL ART ENSEMBLE (1998),
*Fleshmachine: Cyborgs, Designer Babies,
Eugenic Consciousness,*
Brooklyn, New York, Automedia

CUBITT, S. (1998),
Digital Aesthetics, London, Sage

CUTTING EDGE (2000),
*Digital Desires: Language, Identity and New
Technologies,* London, New York, I.B.Tauris

DROEGE, P. (ED.)(1997),
*Intelligent Environments—Spatial Aspect of
the Information Revolution,* Amsterdam,
North-Holland

JoDI: Journal of Digital Information
http://jodi.ecs.soton.ac.uk

JOHNSON, S. (1997),
*Interface Culture: How New Technology
Transforms the Way We Create
and Communicate,*
New York, HarperCollins

JORDAN, T. (1999),
*Cyberpower: The Culture and Power of
Cyberspace and the Internet,*
London and New York, Routledge

KATZ, J.E., AAKHUS, M. (2000),
*Perpetual Contact: Mobile Communications,
Private Talk, Public Performance,*
Cambridge, Cambridge University Press

*Leonardo Electronic Almanach:
Art, Science, Technology,*
http://mitpress2.mit.edu/e–
journals/LEA/LEA2002/LEA/index.htm

LEOPOLDSEDER, H., SCHOPF, C. (1997),
Cyberarts, Vienna, New York

LÉVY, P. (2001),
Cyberculture, trans. by R. Bononno,
Minneapolis, London,
University of Minnesota Press

LUNENFELD, P. (ED.)(1999),
*The Digital Dialectic: New Essays on
New Media,* Cambridge, Mass., London,
The MIT Press

MANOVICH, L. (2001),
The Language of New Media,
Cambridge, Mass., London, MIT Press

PLANT, S. (1997),
*Zeroes + Ones: Digital Women +
the New Technoculture,*
London, Fourth Estate

PERRY, N. (1998),
Hyperreality and Global Culture,
London and New York, Routledge

Plateau of Humankind,
49th Venice Biennial (2001),
Venice, Italy (catalogue)

POSTER, M. (2001),
The Information Subject,
Commentary by Stanley Aronowitz,
Amsterdam, Gordon and Breach

SCHOLDER, A., CRANDALL, J. (2001),
Interaction: Artistic Practice in the Network,
New York, D.A.P.

SPIELMANN, Y., WINTER, G. (EDS)(1999),
Image—Media—Art,
Munich, Wilhelm Fink Verlag

TAYLOR, M.C. (2001),
*The Moment of Complexity: Emerging
Network Culture,* Chicago and London,
University of Chicago Press

TAYLOR, P. (1999),
Hackers: Crime in the Digital Sublime,
London and New York, Routledge

WILSON, S. (2001),
*Information Arts: Intersections of Art,
Science and Technology,*
Cambridge, Mass., The MIT Press

YUILL, S. (2001),
Living Zeroes,
http://www.livingzeroes,org

YUILL, S. (2002),
*image.building.word: A Study of the Digital
Artifact,* unpublished PhD manuscript,
Dundee, University of Dundee

Bill Seaman

SEAMAN, B. (1999),
*Recombinant Poetics: Emergent Meaning as
Examined and Explored Within a Specific
Generative Virtual Environment,*
PhD Dissertation, Centre for Advanced
Interactive Arts (CaiiA),
University of Wales, Carleon Campus

SEAMAN, B. (1999),
'Emergent Constructions: Re-embodied
Intelligence within Recombinant Poetic
Networks' in: *Digital Creativity,*
vol. 9, no. 3, pp.153-160

SEAMAN, B. (2000),
'Motioning Towards the Emergent
Definition of E-phany Physics' in:
Art, Technology, Consciousness: Mind@large,
ed. by Roy Scott, Bristol, Intellect

JODI

http://www.jodi.org (homepage)

http://sod.jodi.org

http://untitled-game.org

BAUMGAERTEL, T. (1997),
*We Love your Computer; The Aesthetics of
Crashing Browsers,* interview with JODI,
http://www.heise.de/tp/english/special/ku/
6187/1.html

BAUMGAERTEL, T. (2001),
Interview with JODI,
http://rhizome.org/object.rhiz?2550

MCKEE, F. (2001),
Untitled Game,
http://www.cca-glasgow.com/new_media/
new_media_right_archive.htm

Matthew Chalmers, Matt Locke, Francis McKee

BAKER, R.
http://www.irational.org/rachel

Barbelith Network,
http://www.barbelith.com

BEY, H. (1991),
T.A.Z.: The Temporary Autonomous Zone, Ontological Anarchy, Poetic Terrorism,
New York, Automedia

Bloggers,
http://www.blogger.com

CHALMERS, M. (2000),
'Cookies are not enough—Tracking and Enriching Web Activity with a Recommendation System', in: *Preferred Placement: Knowledge Politics on the Web*, ed. by R. Rogers,
Maastricht, Jan van Eyck Academie

CHALMERS, M.
http://dcs.gla.ac.uk/-matthew (homepage)

Counter-Strike,
http://www.counter-strike.net

Equator,
http://www.equator.ac.uk

HILLIER, B. (1996),
Space is the Machine: A Configurational Theory of Architecture,
Cambridge, New York and Melbourne, Cambridge University Press

KIMBELL, L. (2001),
Cellular Flanerie,
http://www.lucykimbell.com

LOCKE, M.
http://www.the-media-centre.co.uk

MCKEE, F.
http://www.francismckee.com,
(home page)

Napster,
http://www.napster.com

RABY, F. (2001),
Project-26765: Flirt,
London, Royal College of Art

ROSEMARY, S. (2002),
'Mobile Zone',
[a-n] MAGAZINE, February, pp. 22-24

SIDHU. J. (2000),
'Text Messages Take Centre Stage',
BBC News,
http://news.bbc.co.uk/l/hi/entertainment/88rewo.stm

Slashdot,
http://slashdot.org

Speakers Corner,
http://www.speakerscorner.org.uk

WEISER, M. (1995),
'The Computer for the 21st Century' in: *Scientific American Special Issue*

Judy Spark

Message Sent (2002),
The Travelling Gallery, City Arts Centre, Edinburgh (catalogue)

MOORE, S. (1999),
Millennium Spaces Report,
Landscape Design Trust

RATTAY, F. (1999),
'Never the Bridge', in:
Blueprint,
Art Aspen Publisher

Shave (1998),
Somerset, UK

SPARK, J. (2000),
The Precautionary Principle,
The Millennium Foundation, Glasgow, Remote

The City and the River,
Royal Institute of British Architects, London

Cornelia Sollfrank

Old Boys Network (1997)
First Cyberfeminist International,
Kassel

OLDENBURG, H., VON REICHE, C. (EDS)(2002),
Very Cyberfeminist International,
Berlin
b_books

SOLLFRANK, C. (ED.)(1999),
Next Cyberfeminist International,
Berlin

http://obn.org (homepage)

RTMark

JORDAN, T. (2002),
Activism!: Direct Action, Hacktivism and the Future of Society,
London, Reaktion

MEYERS,W. (2000),
Santa Clara Blues: Corporate Personhood v. Democracy,
http://www.iiipublishing.com/afd/Coperson.html

http://rtmark.com (homepage)

Com & Com

C-Files: Tell Saga— Das Buch zum Film (2000),
Zurich, edition fink (artist book)

Geld und Wert—das letzte Tabu (2002),
Zurich, Expo 02 (catalogue)

Identity. Trademarks, Logotypes and Symbols,
Stockholm, Swedish National Museum of Fine Arts (catalogue)

SZEEMANN, HARALD (2001),
'Alles was zum Menschsein gehört', in:
Kunstforum International, vol. 156, August

The Book of Com & Com,
Zurich, edition fink (catalogue)

The Odyssey (2001/1998),
Zurich, edition fink

http://www.comcom.ch (homepage)

http://www.tell–star.ch

Santiago Sierra

Santiago Sierra: Works 2002 on 1990 (2002),
Ikon Gallery, Birmingham (catalogue)

Ars 01 (2002),
Kiasma Museum of Contemporary Art, Helsinki

The 1st Bienal of Valencia (2001),
Valencia

Trans Sexual Express (2001),
Barcelona

Santiago Sierra (2001),
text by Taiyana Pimente,
Zurich, Galerie Peter Kilchmann

Marking the Territory (2001),
Dublin, The Irish Museum of Modern Art

Lee Bul

http://www.leebul.com *(homepage)*

Yasuko Toyoshima

Department Store of Contemporary Art (2000),
 text by Shingo Jinno, Yamanashi
 Prefectural Museum (catalogue)

LITTLEJOHN, J. (1998),
 *International Artist in Residence
 Programme Guernsey,* Guernsey College
 of Further Education, UK (catalogue)

NAKAMURA, U. (2000),
 'Yasuko Toyoshima', in: *Saison Art
 Programme Journal,* No 2., Seson Museum
 of Modern Art, Tokyo, 2000

TAKAMI, A. (1999),
 'Yasuko Toyoshima', in: *BT* (Bijutsu Techo),
 vol. 51, no. 769, April

'The Recommendation of "I" Art' in.
 Art in Tokyo No. 9 (1997), text by M. Ozaki,
 Tokyo, Itabashi Art Museum (catalogue)

TOYOSHIMA, YASUKO (1999)
 'Art in Tokyo No. 21', in:
 Saison Art Programme Centre,
 Japan, Takanawa Art Museum (catalogue)

Cary Peppermint

http://www.restlessculture.net (homepage)

Nina Pope

http://www.somewhere.org.uk (homepage)

HARFORD COMMUNITY COLLEGE LIBRARY
401 THOMAS RUN ROAD
BEL AIR, MARYLAND 21015-1698